WINOLD REISS
AND THE CINCINNATI
UNION TERMINAL

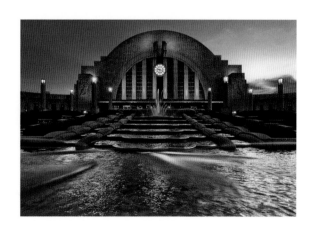

FANFARE FOR THE COMMON MAN

GRETCHEN GARNER

OHIO UNIVERSITY PRESS ATHENS

WINOLD REISS

AND THE CINCINNATI
UNION TERMINAL

Ohio University Press, Athens, Ohio 45701

ohioswallow.com

© 2016 by Ohio University Press

To obtain permission to quote, reprint, or otherwise reproduce or distribute material from Ohio University Press publications, please contact our rights and permissions department at (740) 593-1154 or (740) 593-4536 (fax).

Printed in the United States of America

Ohio University Press books are printed on acid-free paper ∞™

26 25 24 23 22 21 20 19 18 17 16 5 4 3 2 1

The author and publisher gratefully acknowledge the support of Furthermore: a program of the J. M. Kaplan Fund.

Library of Congress Cataloging-in-Publication Data

Names: Garner, Gretchen, author.
Title: Winold Reiss and the Cincinnati Union Terminal : fanfare for the common man / Gretchen Garner.
Description: Athens, Ohio : Ohio University Press, 2016. | Includes bibliographical references and index.
Identifiers: LCCN 2016019901 | ISBN 9780821422021 (hardback) | ISBN 9780821422038 (pb)
Subjects: LCSH: Reiss, Winold, 1886–1953—Criticism and interpretation. | Cincinnati Union Terminal (Cincinnati, Ohio) | Decoration and ornament, Architectural—Ohio—Cincinnati—History—20th century. | Mosaics—Ohio—Cincinnati—20th century. | BISAC: ART / General. | ART / History / General. | ARCHITECTURE / General.
Classification: LCC NA3860.R45 G37 2016 | DDC 738.5/2092—dc23
LC record available at https://lccn.loc.gov/2016019901

CONTENTS

PREFACE

A S A STUDENT of the arts, writer, and photographer, I have seen some wonderful, memorable works of art and architecture. Many have excited me as unique and beautiful, and I have carried an enthusiasm for them over many decades. When I first saw the Cincinnati Union Terminal (well into my eighth decade) I could hardly believe it—the gorgeous rotunda and the enormous mosaic murals by Winold Reiss were like nothing I had ever seen. When I went to the bookstore to get a book on them, I was disappointed to find only an issue of the *Queen City Heritage*, dated 1993.[1] That assembly of essays is still the best thing in print, but where was the book that put them in the context of Reiss's other work—his portrait and design work—and also the artistic and political context of the time, the 1930s? There were titles on the history of the building, which is fascinating, but my focus was Winold Reiss and his murals.

Library and online research has led me to many resources and collections, but all that research just tells me the need is even greater for a book that brings the threads together. This is what I have tried to do in this volume, centering on the rotunda murals. Cincinnatians know and love the murals if they visit the Cincinnati Museum Center (the new name of the terminal), but many others have never heard of them.[2] Likewise, Winold Reiss was very famous in the 1920s to 1940s, but now is one of those artists barely remembered. Several other scholars are hard at work on Reiss and the many aspects of his thought and art. Much interesting work is bound to result.[3] My good fortune of living in Ohio has made the Cincinnati Terminal a natural focus for my research, and every discovery has been a pleasure.

Cincinnati itself is a delight. A city of many picturesque hills with a first-class river, it was first settled in 1788, when after the War of Independence Congress offered Ohio lands for sale. The city was ambitious from the start to be a major

metropolis. John Cleves Symmes, a Revolutionary War officer from New Jersey, purchased all the land that would eventually become Cincinnati and Hamilton County, and he and some fellow officers led the first settlers west. Blessed by the great Ohio River as an important commercial shipping venue, Cincinnati anchored its position in southwest Ohio as *the* important central city in the country. The river was the borderline between north and south during the Civil War, which made its location essential for trade (some of it illicit) during that period. Manufactories sprang up and, away from the river, abundant forests and fertile farmland provided needed raw materials. By 1840, Cincinnati was the fastest growing city in the United States, ranking sixth in population and third in manufacturing. Soon dubbed "The Queen City of the West," it was the gateway city to those traveling further west. Cincinnatians were proud of the new architecture, parks, and engineering marvels like John A. Roebling's 1866 suspension bridge that connected Northern Kentucky with Ohio.[4]

Although Cincinnati has continued to be a thriving, vibrant metropolis, today it has been bypassed in numbers and commercial impact by many other cities in the Midwest and West, even in Ohio, where both Cleveland and Columbus are now larger. Nevertheless, civic spirit has always remained strong, and one of its most striking expressions was the Cincinnati Union Terminal, completed in 1933 and now regarded as the last great train terminal in the country and a magnificent example of Art Deco architecture and design. It is within the great terminal that Winold Reiss created the vast murals that are the subject of this study.

ACKNOWLEDGMENTS

WANT TO THANK everyone who has helped along the way. To start, I thank Professor Gabriel Weisberg and his devoted graduate students for their pioneering work on saving the terminal in the early 1970s, when it was truly in danger of destruction. The late Frances Crotty was especially dogged in her research and contribution to our knowledge of the terminal. At the Museum Center (the current name of the terminal), many have helped me: Linda Bailey, Scott Gampfer, Hillary Begley, Theresa Leiningen-Miller, and Christine Engels.

Renate Reiss, at the Reiss Partnership, has been not only a careful and meticulous reader of the manuscript but also a most generous source of images and documents related to Reiss, and a gracious host at her rural New York home and archive of the Reiss material.

Friends have politely endured my discussion of Reiss and the murals—you know who you are—and some have read versions of the manuscript and offered helpful comments: thanks to Helen Ackery, Sue Howson, Dave Fowler, Sharyn Udall, Gabe Weisberg, Gay Hadley, Thelma Wurzelbacher, and Gregory Thorp. My daughters have been consistently supportive of this project. Laura Saale even drove me to Washington, DC, so we could inspect the Emanuel Leutze mural up close—a trip we both enjoyed. Helen Ackery, editor extraordinaire, has always been ready to read text and correct punctuation. And, as always, thanks to librarians everywhere.

At the Ohio University Press, I am indebted to Director Gill Berchowitz and Editor Rick Huard, who have labored to put this book in your hands.

PART
ONE

THE MURALS

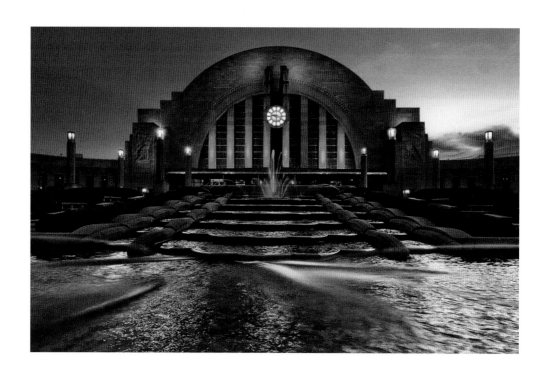

1.1. THE CINCINNATI UNION TERMINAL AT SUNSET,
1301 WESTERN AVENUE.

Principal architects Alfred T. Fellheimer and Steward Wagner, 1933.

Photo by Robert Webber

THE BUILDING

APPROACHING THE Cincinnati Union Terminal, we drive up a gentle slope toward a provocative structure at the crest of the hill. A cascading waterfall breaks up the divided road near the building. The terminal itself cuts a splendid figure of Art Deco geometry, a bell curve in the middle with curving window-studded arms reaching out on either side, silhouetted against the sky. The arms extend out from stepped shoulders recalling Mayan pyramids, fronted by shallow relief sculptures by Max Keck that symbolize transportation and commerce.

The day view is dramatic; at dusk or dawn it's even more spectacular. The main façade is a smooth span of limestone, and the nine tall windows in the wall are set within a perfect semicircle. Stepped piers at either side of the façade buttress its center, and a large lighted clock (it was a train station, after all) punctuates the center of the windows. A generous overhang once sheltered arriving and departing passengers.

An almost uncanny precedent for the Cincinnati Terminal entrance was Eliel Saarinen's Helsinki Central Railway Station (1904–14). In particular, its massive semicircular front entrance, with its large curved window (punctuated by a clock) and generous overhang, predicts Cincinnati. Saarinen's four stone figures, two on each side of the door, likewise predict the Max Keck sculptures. But the Cincinnati interior half-dome was its own creature and unique for its time—indeed, for forty years it held the record as the largest half-dome in the world. While Helsinki's massing of the stone and deeply cut windows create an impression of heaviness, the

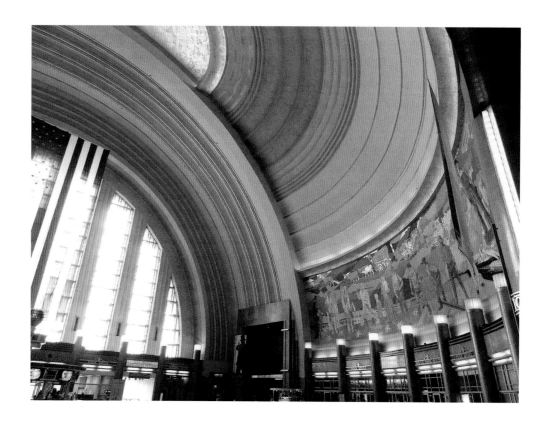

1.2. THE INTERIOR OF THE ROTUNDA.

Color scheme and murals by Winold Reiss.

Photo by author

Cincinnati Terminal—though larger—has a sleek, lighter feel. Still, Saarinen was an early Modernist and established a prototype for Modernist stations to come.

The terminal was designed by Alfred Fellheimer (1875–1959) and Steward Wagner (1886–1958), notable architects of train stations. In their portfolio already were stations for Buffalo, Greensboro, Winston-Salem, and South Bend. Paul Philippe Cret (1876–1945) and Roland Wank (1898–1970) were design associates on the Cincinnati job.[1]

Fellheimer had earlier been part of the firm of Warren and Wetmore that had designed the magnificent and complex Grand Central Station in New York (erected 1903–12). Fellheimer and Wagner's style was flexible and gradually evolved from neoclassic to Art Deco, culminating in the Cincinnati Union Terminal, which was the last of the great American train stations, and probably the high point of their design careers.

Functionally, Fellheimer and Wagner were visionaries of great train stations as gateways and crossroads, designing with an eye to "the practical, economical resolution of traffic-flow patterns with 'multi-level, multi-use spaces.'"[2] Opened in 1933, the Cincinnati terminal served a public needy of train travel, and probably was at its peak in the World War II years. After the war, though, the automobile gained ascendance and the terminal was shut down on October 28, 1972, because of the steep falloff in passenger traffic. The automobile and the interstate highways had taken their toll; but, still, the station's beauty has remained. And, in the middle of the night, one Amtrak train still comes through, connecting Cincinnati to Chicago to the west, and Washington and New York to the east.

Stepping inside, we enter a breathtaking rotunda. At 180 feet wide and 106 feet high, when it opened in 1933 it was the largest unsupported half-dome in the world. The Sydney Opera House later took that title when it opened in 1973, but the terminal rotunda is still the largest in the Western Hemisphere.[3] The interior shell of the rotunda is made of circling bands of yellow-to-gold stucco, divided by narrow bands of silver paint. Shops and offices (once ticket offices) line the curved walls on the ground floor, and a large information kiosk centers the space. Most remarkable, two enormous mosaic murals by artist Winold Reiss divide the huge room, each 105 feet wide (Reiss also created the ceiling and the floor designs). Complementing the gleam of the mosaics are the sleek and modern materials used on the first level— polished granite and nickel silver, with polished terrazzo floors inlaid with an Art

Deco circular pattern designed around thin brass dividers. Around the outer edges of the rotunda the shiny granite columns are topped with lights that are something like torches, but also similar to stage footlights for the murals.

A note to the reader: The building is now called the Cincinnati Museum Center, but throughout I have mostly used the name Cincinnati Union Terminal, since that was its original name and purpose.

THE TERMINAL'S HISTORY

Before the Cincinnati Union Terminal, seven railroads had served their passengers at five different stations scattered over the city: the Baltimore & Ohio Railroad, Louisville & Nashville Railroad, Cincinnati Southern Railway Company, New York Central Railroad, Chesapeake & Ohio Railroad, Norfolk and Western Railroad, and Pennsylvania Railroad. With five stations, there were bottlenecks and annoying transfers, not to mention the frequent flooding of the Ohio River which put one or another station out of commission from time to time.

In the early 1920s far-sighted industry leaders began planning one central terminal, and luckily they chose a point high enough to be out of the way of floods, a piece of land that was further raised by infill. In 1927, George Dent Crabbs, founder of the Union Terminal, completed negotiations with the seven railroads to construct one terminal to serve them all. The New York firm of Fellheimer and Wagner, already famous for its railroad stations, was chosen as architect, and accepted the commission in June 1928. Construction began in 1929.

The cost of the terminal was $41 million, including land, infill, and construction, including several ancillary buildings. Even today, such a cost would be impressive, but in Depression days it was truly remarkable. Yet all the moneys were privately raised—no state or federal dollars. The terminal provided many jobs, so of course it was a boon to the economy of Cincinnati.

The cornerstone was laid in 1931 and the terminal began service on March 19, 1933. Ironically, the very day of the dedication there was a flood, but the terminal rose above it. Another flood in January 1937 devastated Cincinnati: "On January 26, the river crested at 80 feet. Forty-five square miles of Hamilton County were under water; 61,600 Cincinnatians were homeless."[4] But, again, the rotunda of the station rose above the surrounding floodwaters. However, during the 1937 flood only two of the seven railroads—the Chesapeake & Ohio and Cincinnati Southern— were able to continue uninterrupted service, because the other railroads with tracks on low ground could not come into the city.[5]

Business slowed after World War II, when the terminal had seen incredible traffic, and in 1972 the terminal was closed. Punctuating its downtime, one use for the building was as a shopping center. In 1990, it took on its current role, housing several museums and an IMAX theater.

The most dramatic change in the early 1970s was the destruction of the concourse —the long arm that led to the various tracks—so that piggyback double freight cars could come through. In terms of art, this meant the removal of the fourteen industrial/worker murals Winold Reiss had created, each depicting a notable Cincinnati business. The murals—after a successful "Save the Terminal" effort by the community—were moved to the Cincinnati/Northern Kentucky International Airport, where they have been since then. This was a herculean effort—each 20' × 20' mural weighing eight tons—and they were trucked upright to protect them from cracking.

Now, however, with two of the three airport terminals scheduled for destruction, nine of the murals must be moved again. Mayor Mark Mallory, whose term as mayor is just completed, favors bringing them "home" to the convention center, and there is another community effort under way to make this happen.

ART DECO

IN THE FIRST decades of the twentieth century, public architecture—banks, libraries, train stations, theaters, museums, universities—was dominated by the Beaux-Arts movement.[6] This neoclassic style took its name from the École des Beaux-Arts in Paris, where many of the artists and architects of the period had studied. The style quoted freely from classical motives, or *motifs*—especially Roman and Renaissance: columns, pilasters, arches, pediments, great central halls, classical domes. Stone was the preferred building material, and historic grandeur was the aim.

There were important precedents to the movement in the ideas and buildings of Andrea Palladio in the sixteenth century, and, much earlier, in the Roman architect Vitruvius.[7] Decorations were limited to classical or ideal figures, in paint, sculpture, and even in architecture. The architectural historian Linda Oliphant Stanford has written, "The term Beaux-Arts is used . . . to refer to the essential attitude many American architects held toward design. Their preference was for monumental well defined spaces, prominent hieratic axes, and clearly articulated masses."[8]

A prime example of the Beaux-Arts style is Grand Central Station in New York, where travelers step into a huge, stunning central hall before scurrying to the various levels and tracks where their personal journeys take them. Beyond New York, many cities have their own examples of buildings of the era, with great central halls, plenty of polished marble, and colonnades and grand staircases recalling the grandeur that was Rome.

World War I made this backward-looking style beside the point. The world needed a new vision. Artists in other fields created new styles: Cubism, Futurism, Expressionism, Surrealism, among others. Architects and designers, too, realized that quoting the past was pointless. They ushered in the era of streamlined, modern forms, called "modernism" by its first practitioners, eventually called Art Deco in the twenties and thirties, pioneered in Europe but soon after popular in North America.[9]

The sources of the new designs were often found in non-European cultures and in sculptural decoration that was often flat or somewhat abstract in effect. As Patricia Bayer has observed,

> The influence of the Mayan and Aztec and Native American cultures, largely confined to the New World, was manifested in a variety of twentieth-century buildings in the United States, Canada and Mexico. The Mexican Revolution, which began in 1910, further spread the appeal of traditional styles and motifs, namely, stepped pyramids (such as those at Chichen Itza and Uxmal), deities in elaborate headdresses and costume, stylized sunrays . . . and dense patterns of circles, snakes, curlicues and geometric shapes.[10]

It takes no stretch of the imagination to recognize that, in Reiss's murals, the vivid colors of the mosaics and the stepped dome, the abstract "rays" of the sky background, not to mention the colorful costumes of the mural characters (including American Indians), had references to this influence. The stepped sides of the exterior façade also display the Mayan influence.

The later, more severe, plain International Style that came out of the Bauhaus would come to dominate the skyscrapers of the midcentury, as well as furniture and industrial design, but during the twenties and thirties Art Deco—with its color and complex geometry—was ascendant.

The term Art Deco was not in common parlance until the 1960s, but it harked back to the 1925 Exposition Internationale des Arts Décoratifs et Industriels Modernes. This sensational Paris exhibition brought together the most advanced design work in Western countries, but included neither Germany (which had not been invited) nor the United States (which declined to participate).[11] The various exhibition halls were remarkable for their unusual designs. Strong central doorways and strange domed or set-back roofs leading upward evoked the Mayan and Asian stepped pyramids that were influential among the architects. Semicircular and rectilinear

forms predominated—gone were the classical forms and humanistic realism of the Beaux-Arts and the sinuous curves of Art Nouveau, a late nineteenth-century decorative style.

When the Cincinnati Union Terminal was created in the early thirties, the cost perspective alone made the new modern style more attractive than the Beaux-Arts style. Even so, the project cost $41 million. This included land and infill as well as the building.[12] Early plans for a traditional Beaux-Arts station in Cincinnati were scrapped after the 1929 stock market crash and the Great Depression made economic considerations more important. Two years into the project, in 1931, after Fellheimer and Wagner had begun with a more or less Beaux-Arts style, an Art Deco design was finally chosen because it would be sleeker, more modern, and more economic, using contemporary materials. As Chief Engineer Henry M. Waite explained it the day before the dedication in March 1933,

> At first . . . we planned a classical design with pillars, cornices, pilasters, and pedestals. It would have been cold and costly. It would have cost many times what the present terminal cost. . . . We finally decided on this plain type of structure and brightened it with color along the lines of modern decoration and art. . . . We decided that the terminal which leads to all parts of the world should be as bright and gay as the flowers of the open country. And, when we tried the bright colors, the effect was joyous and stimulating.[13]

Art Deco was not just a new style of architecture and design, it was a radical rethinking—in terms of materials, shapes, and a definitively *modern* outlook—that cut its ties with the traditional forms that had been the hallmark of the Beaux-Arts. In many ways, the end of World War I called for a dramatic break from the past, especially in a devastated Europe, and that is what happened. Author Bevis Hillier sums up the style in his 1968 book, *Art Deco*:

> [A]n assertively modern style, developing in the 1920s and reaching its high point in the thirties; it drew inspiration from various sources, including the more austere side of Art Nouveau, cubism, the Russian Ballet, American Indian art and the Bauhaus; it was a classical style in that, like neo-classicism but unlike Rococo or Art Nouveau, it ran to symmetry rather than asymmetry,

and to the rectilinear rather than the curvilinear; it responded to the demands of the machine and of new materials such as plastics, ferro-concrete and vita-glass; and its ultimate aim was to end the old conflict between art and industry, the old snobbish distinction between artist and artisan, partly by making artists adept at crafts, but still more by adapting design to the requirements of mass production.[14]

Hillier's description of Art Deco is accurate except in one respect. Art Deco frequently uses curvilinear forms, with the Cincinnati Union Terminal providing striking examples.

European-trained artists were in the forefront of the movement. When Winold Reiss immigrated to the United States, he brought a whole new way of thinking about design with him, provided by his excellent art education in Munich. Reiss had been exposed to the Jugendstil of northern Europe, as well as Fauvism, Cubism, German Expressionism, the Blaue Reiter, and the modern decorative arts movement. His important teachers, Franz von Stuck and Julius Diez, had broadened Reiss's perspective to include a bold, colorful approach.

Brilliant color was a trademark with Reiss. In a 1915 essay on "The Modern German Poster," he explained to his readers the brilliance of the new German printing techniques, which he called "DECORATIVE ART." Reiss did not shy away from the word "decorative" and stressed that, for its effects, bold color came first: "The color is the first impression. The color goes before the subject and makes the eye joyful and happy." In the same essay, Reiss defended his own work, a combination of commercial and fine-art jobs, by saying "No good artist is ashamed to do something because it is used as a commercial aid. Their field is not limited. Their education says 'do everything, but do it well.'"[15] (See figures 2.2–2.6.)

In 1930, Reiss was invited to submit designs for the decorations of the Cincinnati Union Terminal, and the architects chose him for the job, with the support of interior consultant Paul Philippe Cret.[16] Also in the running was Pierre Bourdelle, a French artist whose unusual jungle-themed incised linoleum murals (and oil-on-canvas ceiling murals) eventually decorated several spaces in the station. Some are still extant there. But Reiss was given the most important and sweeping assignments in the terminal. Reiss was responsible for 11,908 square feet of artwork in the terminal, and Bourdelle created 5,496 square feet of artwork for the site.[17]

Winold Reiss's extensive commercial interior experience as well as his fame as a modern designer and portrait artist in the 1920s made him well-suited for the job (see Part Two). With his many commercial projects (shops, restaurants, hotels, graphic design, illustration) as well as his interest in human "types" and his substantial portrait portfolio, Reiss was a perfect choice for the decorations. What is more, when he argued for mosaics instead of oil paintings, he was wiser than his clients then realized: because the mosaics could be scrubbed and cleaned to retain their bright color, as they have been, they remain brilliant today.

It might seem that the huge mosaics in Cincinnati had no precedent in Reiss's work, yet in 1929 Reiss was already preparing for three large mosaic murals in the Chrysler Building in New York, although that job was canceled after the stock market crash.[18] In 1930 he had created two large portraits of the Blackfoot Indian Mike Little Dog, at Ravenna Mosaic Company in their signature "silhouette mosaic" technique (see figure 3.1). One of these was used as a sample when Reiss presented his designs to Fellheimer and Wagner. There is a 1983 account by Owen Findsen in the *Cincinnati Enquirer*:

> When the designers of the Union Terminal began their search for an artist to create the giant murals in the Terminal rotunda and on the walls of the arcade, Reiss created a portrait of Blackfoot Chief Mud Dog [*sic*]. The portrait, which won Reiss the Terminal project, is done in glass and mosaic tile embedded in masonry.[19]

As Jeffrey C. Stewart has described the process,

> The architects were impressed by Reiss's translations of the photographs of Cincinnati industries into brightly colored drawings for the concourse mosaics. They consequently handed over to him responsibility for designing the Art Deco floor and, most important, the wall in the rotunda on which a history of transportation in Cincinnati was to be rendered in mosaic. . . . The central design motif of the wall presents the narrative account on three stylistic levels from the realistic, monumental foreground figures, to a somewhat stylized middle ground with covered wagons and other forms of transportation on a reduced scale, to a completely abstracted background that evokes the development of transportation from Indian dog travois to the airplane.

Tjark Reiss [Winold's son] recalls that the commission started first with sketches, then the sketches got bigger, of course small figure drawings, bigger figure drawings, 30" × 22" board, and then from that the life-size ones. So it was a long, carefully thought-out and planned composition. To save money and also because he thought it looked better, only the figures were in mosaic. The background, the outlines are not full mosaic. Most mosaics you see in antiquity are full mosaics. But he had the idea of doing the main subjects in mosaic and the backgrounds wherever possible in stucco, which would save a lot of money. To further reduce expense, he reduced his fee so that they could apply that to the project.[20] What Tjark Reiss described is the technique of "silhouette mosaic," developed by Paul and Arno Heuduck at the Ravenna Mosaic Company, which was contracted to execute the Cincinnati mosaics. Both glass mosaic and flat colored cement are used to make up the murals.[21]

With its extensive murals and decorations and its sweeping, geometric shape, the terminal was the height of Art Deco in America in 1933, and the last great train terminal built in the United States. The murals are much more than mere decoration. They tell a story about the great nation of which Cincinnati is a major central city. Translated into gleaming glass mosaics, the panoramas make a strong statement—both artistic and historical—about the sweep of U.S. history, the breadth and human variety of the nation, and its ongoing progress in transportation.

A great temple to train travel and to the American "types" who are pictured in the sweep of the murals, the terminal was constructed at what would turn out to be the very peak of train travel in the United States. Even though passenger travel had never been the source of enough revenue relative to its cost—the railroads felt it was more of a service obligation—Cincinnati, like many cities, felt a pride in making its terminal a spectacular gateway. Terminal design in fact became an important part of civic identity.[22] Still, during World War II, passenger service kept the terminal busy until 1944. After the war, train travel fell off dramatically—the car, the interstate, and the commercial airplane were in competition—and by 1972 the terminal was closed and the concourse torn down (but not the rotunda) to accommodate the piggyback freight cars that were the new mode of rail shipping. Luckily, in its current role (since 1990) as the Cincinnati Museum Center, the terminal once again draws significant traffic, and visitors can sit at the lunch tables in the rotunda enjoying the grand, golden dome and the wonderful panorama of the Winold Reiss murals.

THE ROTUNDA MURALS
AND THEIR STORIES

A STEADY PARADE OF vivid historic figures in mosaic move across the foreground of the murals (although only the Revolutionary figures are famous individuals), while an abstracted history of transportation in blues and silver fills the backgrounds. These murals—each 22 by 105 feet—follow the curve of the rotunda. They lean in as the rotunda goes up, and curve around as it makes its way around the semicircle. Twelve colorful figures span the foreground of the north mural, and fourteen across the south wall. The two murals are interrupted in the center by a hallway that once led to the concourse, but the narrative continues across both of them.

Documents do not exist that give a definitive title to the rotunda mosaic scheme. Some say "history of Cincinnati," but that's not quite right. Some say "history of transportation," but again, that doesn't tell the whole story. There is in fact more than one story, and careful examination will reveal many threads. Reiss's own description, of course, is most important. In a letter to W. J. Cameron of the Ford Motor Company dated 1940, Reiss offered his thoughts on the composition:

> The panel on the left [the south mural] expresses symbolically the development
> of our country from the early Indian days to our late industrial era. In the back-
> ground, I have portrayed the history of transportation, so important a feature
> in the American scene. The Indians on the left represent the original inhabit-
> ants of America who greet the healthy and virile pioneers coming over the

1.3. NORTH MURAL, 1933.

Silhouette mosaic, 22' × 105'.

1.4. SOUTH MURAL, 1933.

Silhouette mosaic, 22' × 105'.

prairies. In the pioneer group which includes a typical pioneer family, I have tried to express the courage and fortitude of the man; the loyalty and love of the mother; the wondering romance of the past and future in the eyes of the boy. All these qualities are the foundation upon which America stands.

The railroad builders symbolize the importance of transportation and development in bringing the great areas of East and West together. All this past development leads to our industrial era of the present symbolized by two steel workers against a background of a typical American center of trade and commerce of today.

The panel on the right [the north mural] although expressive of all America is more specifically involved in the expression of the development of the Ohio River Valley and Cincinnati. The background shows the development of the important Ohio River shipping. The figure on the far right and the two soldiers symbolize the early Ohio days. The family group expresses the importance of agricultural development of the Ohio Valley. The boy looks romantically back to those men who made possible the peaceful agricultural development into which his mother gladly leads him. The next three men show the human energy put into shipbuilding, longshoring, etc. The next figure, a river boat captain, is typical of the great river men who were responsible for the successful Ohio River traffic. Modern industry of Cincinnati as of other typical industrial cities is symbolized by the two industrial workers.[23]

We must be grateful that this letter exists, as it provides his own outline of Reiss's scheme—the historical story right and left, with the contemporary world front and center. As a careful observer of the murals, I will expand on this.

Facing the broad expanse of the mosaics, I believe it is most natural to read them from right to left, since most of the figures are facing or moving to the left. We then see that the figures represent characters from Revolutionary times up to Reiss's day, suggesting the early settlement of the country from east to west, or, more narrowly, early settlement of Ohio in the north mural. While the murals do not exactly tell a chronological story—since the contemporary part is right in the middle—there does seem to be a movement to the left. The right (north) mural depicts the East, ending at Cincinnati, and the left (south) mural begins at Cincinnati (or what Reiss called "a typical American center of trade and commerce of today") and describes the opening of the West, ending with the three ceremonially dressed Blackfoot In-

dians who face the settlers, one with his hand raised, apparently in peaceful greeting. The Blackfoot were contemporary friends of Reiss, not historical figures.

My preference is to see the broad band of blue water as the Ohio River, running through both murals, although, as others have pointed out, great oceangoing steamships (as we see in the south mural) never made their way east on the river! The imaginary skyscrapers in the background of the south mural might suggest a city bigger than Cincinnati would ever be, but so be it. I think Reiss wanted to tell two stories, but he used the leftward trend of the figures and the broad blue waters to join them.

The characters, in order, are a woodsman/trapper, two Revolutionary officers, a young farming settler family, a worker with a pickaxe or mattock, two black dock-workers, a riverboat captain, four contemporary construction workers, a railroad engineer, two men laying railroad tracks (flanking a surveyor), a pioneer family of five (a young man, his wife, two small children, and a bearded grandfather), and three Indians.[24] The farthest left of the Indians is Turtle, Reiss's first Blackfoot friend, and the second—with headdress and raised hand—is Middle Rider, another early friend of Reiss. The third was named Chewing Backbone.

The peaceful hand gesture of Middle Rider, the gorgeous ceremonial dress of all three of them, and the simple bow held by Turtle contrast with the manufactured tools and deadly weapons held by all the others, except one of the women, the children, and one black dockworker who is about to hoist a heavy sack. To be sure, no violence is shown, and there is really only one instance of "action"—the seated man on the red I-beam swinging his sledgehammer—but the strong subtext implies that these instruments illustrate just how the West was conquered and the land subdued by white settlers. Right to left, we can see in the hands of the worker/settlers a rifle, two swords, a hand scythe, a long-handled scythe, a pickaxe, a shovel, sledgehammers, an oilcan, a crowbar, a surveyor's transit, a long-handled axe, and another two rifles. Reiss avoided direct depiction of any kind of conflict in his work—and I believe this speaks to his character—but the tools and weapons are a clear indication of who prevailed in the settlement story, and why.

WHO ARE THEY?

W HO ARE THESE characters and why were they chosen? A suggestion of the unfolding of the nation is given, but it's not exactly chronological and no struggles are pictured. Where are the Civil War, slavery, the foreign wars, actual conflict with Indians, let alone the miseries of western migration or the Dust Bowl (then just beginning)? Most big murals and history paintings are centered on conflict or struggle, with a hero at the center, in victory or defeat, or possibly an important treaty being signed. Reiss broke with that tradition. The only war directly referenced is the Revolutionary War, with two portraits displaying the front and back of the handsome officer uniforms (costume was always an interest of Reiss's).

The officer on the left is Arthur St. Clair (1737–1818). He was the largest landowner in western Pennsylvania and the first governor of the Northwest Territory: what is now Ohio, Indiana, Illinois, and Michigan, along with parts of Wisconsin and Minnesota. St. Clair named Cincinnati after the Society of the Cincinnati, an honorary organization of Revolutionary War officers, and he established his home there. Later he served as governor of the Ohio Territory.

Next to him is Robert Patterson (1753–1827). Patterson fought in many actions during the war. Afterward he settled in Kentucky, but moved to the Northwest Territory in 1788, where he became one of the three founders of the city. He eventually settled in Dayton.

The woodsman figure on the right is meant to stand for John Filson (ca. 1747–1788), another founder of Cincinnati who had also written a popular account of the adventures of Daniel Boone. Filson, from Pennsylvania, acquired thousands of acres in Kentucky after the war and moved there. He was active in schoolteaching, mapmaking, and writing about "Kentucke" (as he called it), but eventually, after legal difficulties, he moved to Ohio and purchased eight hundred acres at the future site of Cincinnati, which he named Losantiville. Fortune did not follow him, however, and while on a surveying expedition near the Great Miami River, he disappeared on October 1, 1788, when the party was attacked by hostile Shawnees, and his body was never found. He left no direct descendants and his survey partners transferred his interest to the site of Cincinnati.[25] Reiss portrayed him in woodsman gear to indicate his difference from Patterson and St. Clair, including that he had much more experience in the frontier per se than they did.

Even without a battle, many large murals or history paintings managed to create a tumultuous scene of effort, striving, and misery, which—again—Reiss avoided. A great example of the contrast can be found in Emanuel Leutze's 1862 mural in the Capitol Building in Washington, DC.[26] *Westward the Course of Empire Takes Its Way* is essentially a scene not unlike Reiss's—that is, the settlers are going west—but the differences are remarkable. Leutze referred to the Lewis and Clark trek to the West. It is a 20' × 30' broad scene of crowded oxcarts, tipping dangerously side to side, and of human agony, as the caravan follows an S-curve path in its struggle to get to the top of a mountain. At the bottom, in a broad panel, is a view of the Golden Gate, the destination of the settlers.

Figures in the Leutze mural include William Clark in the left and Daniel Boone in the right oval portraits on the wings of the mural. At the top of the principal tableau, one of their group has seen the other side of the mountain (perhaps the ocean itself) and is waving his hat, with another figure handing up a flag. Reiss's figures, by contrast, seem to be engaged in a stately walk west—on flat ground.

Again in contrast to Reiss, Leutze used several eighteenth-century literary references that frame the scene. At the top appears the phrase "Westward the course of empire takes its way," a line from the poem by Bishop George Berkeley, "On the Prospect of Planting Arts and Learning in America." Below are two more quotations, both from Jonathan Sewall's prologue and epilogue, respectively, to Joseph

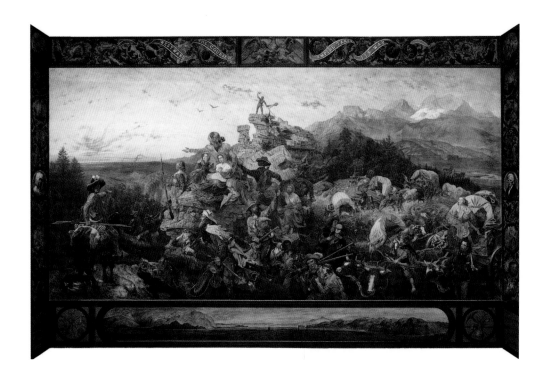

1.5. EMANUEL LEUTZE, **WESTWARD THE COURSE OF EMPIRE TAKES ITS WAY,** 1862.

Stereochrome mural, 20' × 30'. U.S. Capitol.

By permission of the Architect of the Capitol

Addison's *Cato, a Tragedy.* At the base of the left wing we read, "No pent up Utica contracts our powers, but the whole boundless continent is ours"; at the base of the right wing, "The spirit grows with its allotted spaces, the mind is narrowed in a narrow sphere." These quotations frame and justify the westward project of settlement of the continent, making the mural both text and illustration.

Reiss, by contrast, included no texts or even a title, but a closer reading of his characters and their gestures suggests the social history that lies behind them. Starting again with the three right-hand figures, the rough woodsman and the sophisticated Revolutionary War soldiers establish the founding polarities of American life, and particularly the life of Cincinnati—the backwoods individualism of the bearded scout on the far right, and the powdered-wig elegance of St. Clair and Patterson. From this, all else unfolds. Cincinnati was once at the edge of the frontier, but linked irrevocably to the East and always ambitious to be a major city. Indeed, it was a major American city from shortly after the days of its founding.

The next group is a young family, the man wielding a long scythe, taming the wilderness, some land he can claim for himself, while his wife and young son follow behind. The child reaches back to the soldiers with a little flower as he steps awkwardly over a tiny ravine. He doesn't want to go, but his mother tugs him behind her, looking rather distressed, and holding a hand-scythe herself. The father is concentrating intently on his cutting. They are going west. The man with the scythe bears a distinct resemblance to the figure in Winslow Homer's painting of 1865, *Veteran in a New Field* (Metropolitan Museum of Art, New York). Homer's painting focuses on the need for a veteran of the Civil War to move on to a new phase of his life, but it's an open question whether Reiss was referring to pre– or post–Civil War challenges. In either case the family is trying to carve out its own space in the broad continent.

After that, a string of three workers overseen by a riverboat captain in a suit suggest the early industrial development of the Midwest (and its required human capital). Coal mining is likely the occupation of the first worker with the pickaxe or mattock over his shoulder, while the second—a black man holding a shovel—could be engaged in any number of menial tasks.[27] Are he and the next man, about to lift a sack, presumably of cotton, slaves? Hard to tell. During the Civil War, Cincinnati was held by the North, but there was also a strong if semi-illicit cotton trade between North and South centered in the city.[28] Southern growers whose own ports were blockaded could trade their cotton for gold up north—Cincinnati being a key

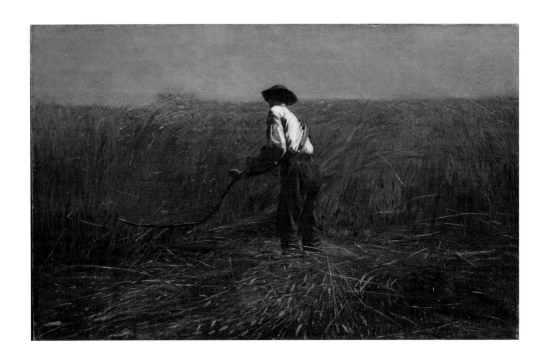

1.6. WINSLOW HOMER, **VETERAN IN A NEW FIELD**, 1865.

Oil on canvas, 24$^{1}/_{8}$" × 38$^{1}/_{8}$". Metropolitan Museum of Art, New York.

Image © Metropolitan Museum of Art. Image Source: Art Resource, New York

center for this trade—continuing to finance their struggle, while the Northern deal-ers could make a huge profit shipping the cotton to New England or overseas. After Emancipation, the men could have been free. In any case, the Cincinnati cotton trade dropped off after the war, and by the 1880s (at least on the Ohio River) it had fallen into severe decline.[29]

Further to the left, four modern construction workers are shown with Cincin-nati in the background—two to the right of the opening to the hallway, and two to the left. These are hefty, muscular, good-looking types in overalls, clearly engaged in building one of the icons of the twentieth century: a skyscraper. (Fantasies of skyscrapers-to-be are designed into the "sky" area behind them.) The two men just left of the center are situated on a red steel I-beam, the very material that made sky-scrapers possible. The terminal itself was built with steel-frame construction, which of course made the size of the rotunda possible. The first worker on the right of the hallway entrance is struggling under the weight of a huge slab of what appears to be the same granite used in the terminal, since it is identical in color. These four figures are the climax of the composition and refer most strongly to the terminal itself, which is not itself depicted, although the methods of construction are heroicized.

The next group of four figures is engaged in the construction and extension of the railroads across the continent. The transcontinental railway lines—the Union Pacific and the Central Pacific—were connected on May 10, 1869, at Promontory, Utah. A golden spike was driven into the last rail and tie, finally connecting the na-tion east to west. A railway engineer with an oil can—the only figure contemporary to Reiss's time—is on the right, and men involved with laying the tracks—hewing the ties, surveying the land, and laying the rails—are to his left.[30] The importance of this group to the mission of the terminal is obvious, since it was a center for this traffic by rail. These common men were among the thousands of unsung heroes of the great project of laying the railway across the country. Many, we know, were Chinese, although no Chinese workers are pictured in the mural.[31]

Then we have a family of five—father and grandfather, both with long guns; mother; and two children—in what appears to be a face-off with the three ceremo-nially dressed Indians.[32] Perhaps the family came west on the train, but from their rough look it is more likely they came west on the covered wagon illustrated in the abstract sky above. They could be homesteaders, going west to stake their claim. The Homestead Act was passed in 1862 and enacted January 1, 1863. Filers for a

homestead were given 160 acres from the federal government in exchange for the promise to farm and develop the land and live on it for five years before gaining title. Many claims were abandoned, and in the dry West it was often discovered that 160 acres were often not enough to sustain a family.[33] The Dust Bowl, then just beginning in the western plains, was a disaster of abandoned homesteads for many.[34]

Finally, there are the three ceremonially dressed Indians, clearly facing the oncoming settlers. These men were Blackfoot and friends of Winold Reiss since January, 1920, when he first visited them in Montana and began his long series of Blackfoot portraits: left to right, they are Turtle, Middle Rider, and Chewing Backbone, and there are many other studies and portraits of these three by Reiss. This section of the mural might seem the most unresolved, because it seems to slight the very real conflicts or at least differing interests between the Indians and settlers. But, in another sense, it is truly revealing of Reiss's own possibly conflicted loyalties—or, more to the point, his developing pacifism. When he first immigrated to the United States, Reiss wanted most of all to paint Indians—because he admired them—and here in permanent mosaic are three magnificent portraits. Another artist might have left them out altogether, but for Reiss they were supremely important. And, high up on the wall, everyone exists in peace.

Some are interested in knowing about the models for these figures, and models indeed there were. Only a few of the foreground figures were based on photographs, Reiss relying much more on personal sketches made in the presence of live models. The Reiss Archives hold nearly a hundred figure studies for the rotunda murals and the industrial murals, along with a study for the rotunda ceiling's bands of yellow to gold. A dancer named Iorne Kincaid was used as a figure model for as many as eighteen characters in the mosaics.[35] Otherwise, we have a few identifications, starting on the far right of the north mural.[36]

> Woodsman, Revolutionary soldiers: Gero v. Gaevernitz, and a Mr. Jones
> Boy: Rudy Baumgarten
> Man with scythe: Tjark Reiss (Winold's son)
> Man with pickaxe or mattock: Howard Pettibone

On the south mural:

> Railroad worker in orange shirt: Tjark Reiss
> Railroad engineer: John Lester

Surveyor: Tjark Reiss
Child (boy): Roy Olsen
Young man with Gun: Hans Reiss (Winold's brother)
Indians: Chewing Backbone, Middle Rider, and Turtle

In the end, it doesn't matter who the models were, but it is a testament to Reiss's working method that they were based on actual figure studies, carefully rendered.

In the middle distance, behind the figures, is an unfolding landscape of America, beginning on the right with small Eastern villages, then across an expanse of empty farmland, then Cincinnati itself (with the broad Ohio River and its busy river traffic bowing out in the center). After that, stretching into the west are plains, ending with a herd of buffalo (with a distant Indian in pursuit) and red-rock mountains. Running through the whole thing—and this is a fanciful conceit of Reiss's—is the blue ribbon of the "Ohio River."

Several means of transportation used in settling the country seem to float in the distant blue and silver sky, with a number of boats and paddle-wheelers on the right, and on the left various types of ground transportation, from dog- and horse-travois to covered wagons to early trains and modern locomotives. A log cabin and a log fort (Fort Washington) anchor the far right of the background. In the center are the imaginary future skyscrapers of Cincinnati (also rendered in blue, gray, and silver), and above them the very latest kinds of transportation (in 1933): a blimp and three airplanes. Ironically, train travel itself—the whole purpose of the building—would in short order be eclipsed by the automobile, but nowhere in this "history of transportation" is there a car to be seen, even on the streets and bridges of Cincinnati!

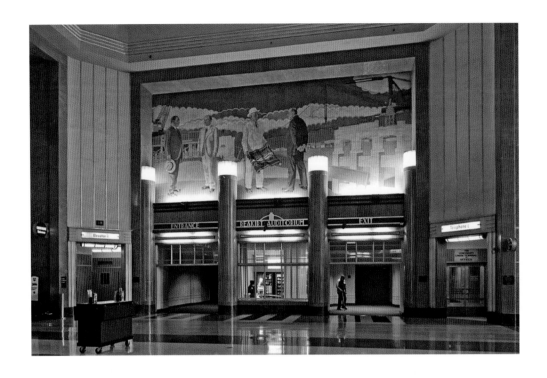

1.7. FOUNDERS MURAL, 1933.

Depicting Murray Seasongood, mayor of Cincinnati when the project began in 1929,
C. O. Sherrill, city manager in 1929; H. M. Waite, chief engineer for the Union Terminal
Company; and George Dent Crabbs, civic leader and founder of the company. Silhouette
mosaic. On the opposite wall is a second founders mural showing Russell Wilson, mayor
of Cincinnati in 1933; H. A. Worcester, first president of the Union Terminal Company; and
C. A. Dykstra, city manager in 1933.

Photo by Stephen Brown

FOUNDERS MURALS

IN THE CENTER—between the two long rotunda mosaics—is a hallway, formerly called the checking lobby. On either side of the hall Reiss created two more mosaics featuring seven of the Cincinnati businessmen and builders who brought the project into being in 1933, but not including, unfortunately, the artist himself. We see on the north side, moving from left to right, with the completed terminal behind, Russell Wilson, mayor of Cincinnati in 1933; H. A. Worcester, the first president of the Union Terminal Company; and C. A. Dykstra, city manager in 1933. On the south panel, also moving from left to right, set against what looks like the original construction site, are Murray Seasongood, mayor of Cincinnati when the project began; C. O. Sherrill, city manager in 1929; H. M. Waite, chief engineer for the company; and George Dent Crabbs, civic leader and founder of the Union Terminal Company.

Although Reiss made many self-portraits, this was a commercial commission and his image appears nowhere. His son Tjark and his brother Hans, though, posed for some of the figures. Reiss could have followed Renaissance precedent (or, for that matter, the example of his contemporary, Diego Rivera) by including himself among the portraits, but he did not. Other differences between Reiss and Rivera are striking and will be explored later on.

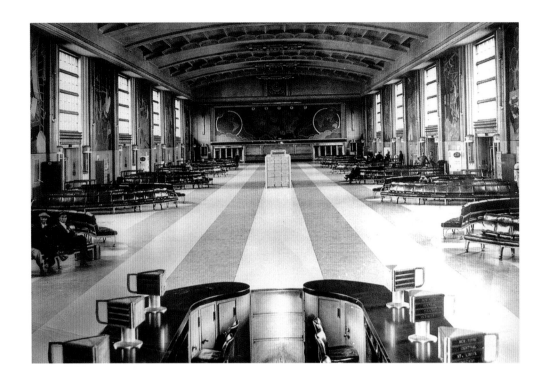

1.8. CINCINNATI UNION TERMINAL CONCOURSE, WITH INDUSTRIAL/
WORKER MURALS BETWEEN WINDOWS AND MAP MOSAIC AT THE END,
1933 (DESTROYED 1972).

Cincinnati Museum Center Library and Archives (SC #20)

THE INDUSTRIAL/WORKER
MURALS

BEYOND THIS HALLWAY was the grand concourse that once led to the tracks for the seven railroad lines that originally met there. Along the concourse were fourteen more mosaic murals designed by Reiss, each depicting a Cincinnati industry, all based on documentary photographs that Reiss made or directed.[37] As in the rotunda, these are "silhouette mosaics," with the figures and main features in mosaic, the rest in colored plaster.

These industrial or worker mosaics have a more documentary feel and focus, compared to the symbolic tableaux of the rotunda mosaics. They tell modern, more descriptive stories, each of a different manufacturing process, proclaiming the many good businesses—and workers—of the region. In terms of composition, the worker mosaics are both much more complex and at the same time more casual than the rotunda mosaics. They are full of complicated diagonals, convincing depth, and varied forms, proof that Winold Reiss could create way beyond the sometimes stiff presentations of individuals in his portraits and the rotunda mosaics. By comparison, the industrial mosaics have a fresh, candid air of action. In the rotunda Reiss generally focused on the individual, giving the background less attention. With the industrial mosaics, workers are embedded in (maybe overwhelmed by) the environment. This is in stark contrast to the figures of the rotunda mosaics.

In the industrial mosaics the figures are shown in action, absorbed in their work. A curious absence is that of women workers. There are no women shown, even though there were women working in the local factories (especially at Rookwood Pottery, a business with many female decorators founded by Maria Longworth), and in at least one of Reiss's study photographs a woman is pictured (the photo made at the United States Playing Card Company). Likewise, African American workers are conspicuous by their near absence. There seem to be two in the Procter and Gamble mural, and just one is shown in the Merrell pharmaceuticals mural. This absence of diversity would be a misstep by today's standards of equal representation, but at the time was less remarkable.

Each of the industrial / worker mosaics was based on a black-and-white photograph made under Reiss's direction. The photographs were flash-lit and contained no color information. When they appeared as mosaics, the colors were vivid and doubtless transformed from the "true" colors Reiss would have witnessed on the sites. Industrial sites were not noted for color in this era. This shows a balance Reiss was able to achieve between what he observed and his own creativity, and no doubt the Ravenna mosaicists added their own intensity to the colors. As Arno Heuduck of Ravenna Mosaic described the process in a letter of July 1972,

> We receive the full-size drawings from the artist which are usually done in flat color areas. From these we make a reverse line tracing which we term our shop drawing. This shop drawing we then cut into various shaped sections (about 2-square feet or so). It is on these sections that the mosaic craftsman adheres the individual mosaic tessera with a paste to this paper. This entire translation of the cartoon into the mosaic medium is done in reverse (pasting the finished side of the mosaic to the face side of the paper), when all the mosaics are completed in the studio, we ship them to the building site. We then send our own mosaic craftsmen to the job to do the actual installation of the mosaics. We of course hire local laborers etc. to help. The Cincinnati Terminal Mosaics are rather unique in that they are done in what we term our "Silhouette Mosaic." Because the mosaic area itself is mainly confined to the actual design and figures, etc., whereas the background or field is a textured and colored concrete. . . .
>
> The cartoons (full-size color drawings) from Winold Reiss were in full size, but as mentioned previously, carried out in solid color design. He left it to the mosaic craftsmen to make each area interesting within itself with a

mélange of color and color accents. We carry some eight thousand different colors of this hand-cut smalti mosaic material in our studio, which as any artist will know, is most important.[38]

Each of the 20' × 20' industrial/worker mosaics features one or more workers at the following Cincinnati companies, with the equipment and workmen displayed in graphic, colorful glass tesserae:

William S. Merrell, pharmaceuticals
E. Kahn's and Sons (meatpacking)
American Laundry Machinery
Crosley Broadcasting
Cincinnati Milling Machine
American Steel Foundry
Philip Carey Manufacturing (whose president, George Crabbs, negotiated
 the agreements with the seven railroads to build the terminal)
Aeronautical Corporation of America, assembling an Aeronca plane at
 Luken Airport
United States Playing Card Company and Champion Coated Paper
Ault and Wiborg Ink and Varnishing Works
Andrews Steel Rolling Mill, Newport, Kentucky
Baldwin Piano
Procter and Gamble (making soap)
American Oak Leather
Rookwood Pottery (two smaller mosaics)
Arrivals and Departures (two smaller mosaics, no workers shown)[39]

At the very end of the concourse was a huge, beautiful mosaic map of the United States, with time zones. Unfortunately, this map was too large to be saved and was destroyed when the concourse was demolished.

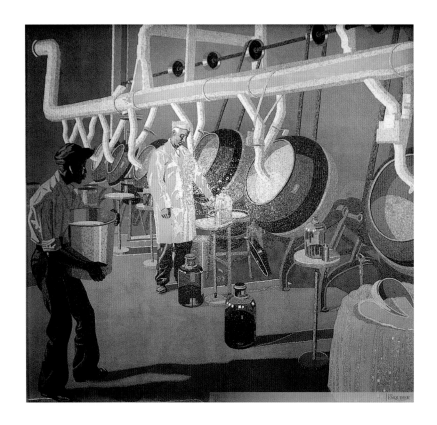

1.9. INDUSTRIAL/WORKER MURAL: WILLIAM S. MERRELL
(PHARMACEUTICALS), 1933.

Silhouette mosaic, 20' × 20'.

Photo by Glenn Hartong. Figures 1.9–1.22 from THE CINCINNATI
ENQUIRER, April 8, 2013 © 2013 Gannett-CN. All rights reserved. Used by
permission and protected by the Copyright Laws of the United States. The
printing, copying, redistribution, or retransmission of this Content without
express written permission is prohibited.

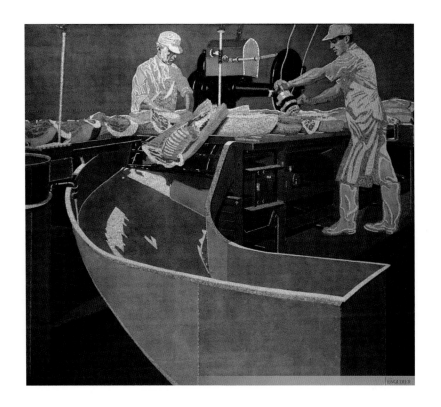

1.10 INDUSTRIAL/WORKER MURAL: E. KAHN'S AND
SONS (MEATPACKING), 1933.

Silhouette mosaic, 20' × 20'.

Photo by Glenn Hartong, CINCINNATI ENQUIRER

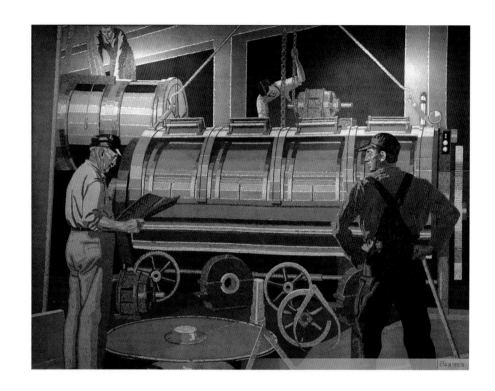

1.11. INDUSTRIAL/WORKER MURAL: AMERICAN
LAUNDRY MACHINERY, 1933.

Silhouette mosaic, 20' × 20'.

Photo by Glenn Hartong, CINCINNATI ENQUIRER

1.12. INDUSTRIAL/WORKER MURAL: CROSLEY
BROADCASTING, 1933.

Silhouette mosaic, 20' × 20'.

Photo by Glenn Hartong, CINCINNATI ENQUIRER

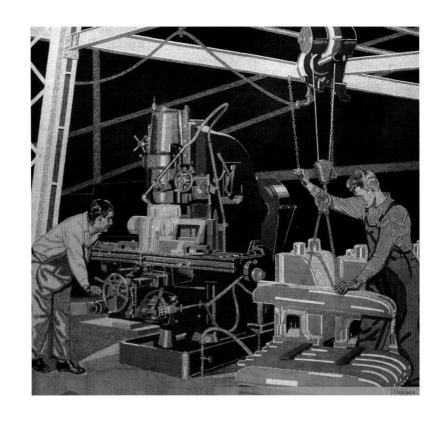

1.13. INDUSTRIAL/WORKER MURAL: CINCINNATI
MILLING MACHINE COMPANY (TOOL MANUFACTURE),
1933.

Silhouette mosaic, 20' × 20'.

Photo by Glenn Hartong, CINCINNATI ENQUIRER

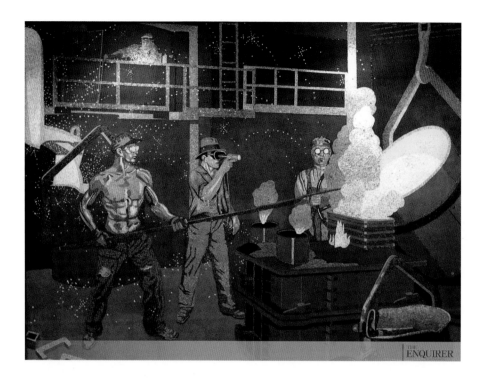

1.14. INDUSTRIAL/WORKER MURAL: AMERICAN STEEL
FOUNDRY, 1933.

Silhouette mosaic, 20' × 20'.

Photo by Glenn Hartong, CINCINNATI ENQUIRER

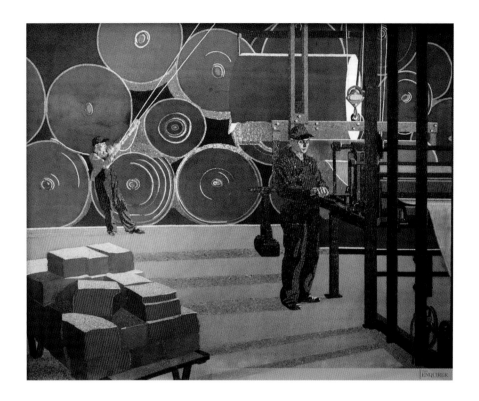

1.15. INDUSTRIAL/WORKER MURAL: PHILIP CAREY MANUFACTURING (INDUSTRIAL INSULATION), 1933.

Silhouette mosaic, 20' × 20'. George Crabbs, the CEO, negotiated the agreements between the seven railroads to build the terminal.

Photo by Glenn Hartong, CINCINNATI ENQUIRER

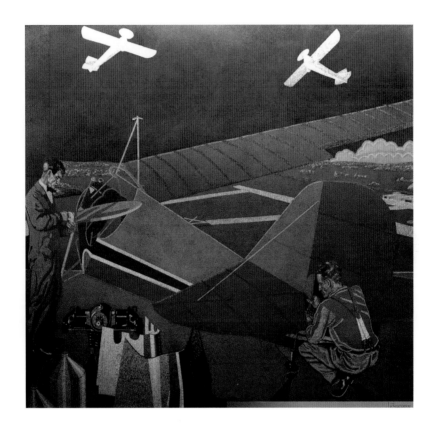

1.16. INDUSTRIAL/WORKER MURAL: AERONAUTICAL
CORPORATION OF AMERICA (AIRPLANE
MANUFACTURE), 1933.

Silhouette mosaic, 20' × 20'.

Photo by Glenn Hartong, CINCINNATI ENQUIRER

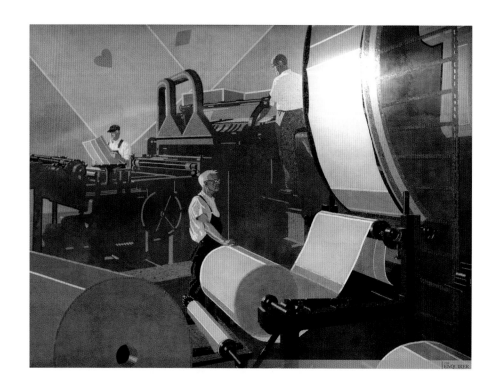

1.17. INDUSTRIAL/WORKER MURAL: UNITED STATES
PLAYING CARD COMPANY AND CHAMPION COATED
PAPER, 1933.

Silhouette mosaic, 20' × 20'.

Photo by Glenn Hartong, CINCINNATI ENQUIRER

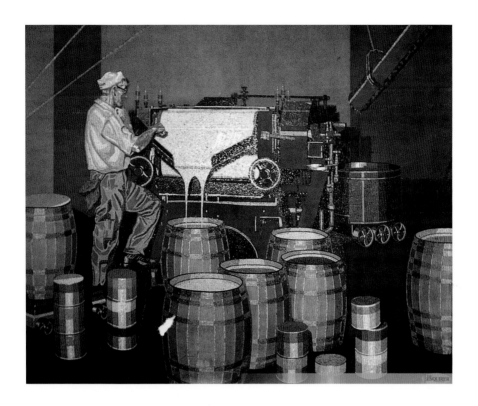

1.18. INDUSTRIAL/WORKER MURAL: AULT AND WIBORG (INKS AND VARNISHES), 1933.

Silhouette mosaic, 20' × 20'.

Photo by Glenn Hartong, CINCINNATI ENQUIRER

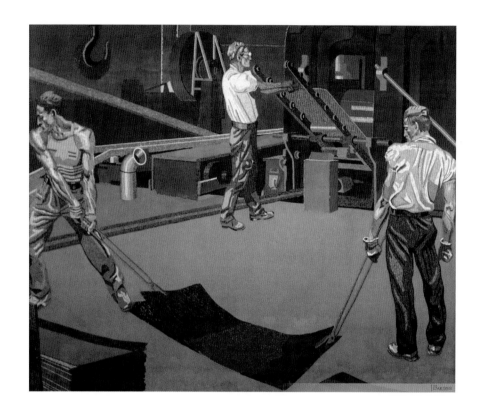

1.19. INDUSTRIAL/WORKER MURAL: ANDREWS ROLLING
MILL (STEEL MANUFACTURE), 1933.

Silhouette mosaic, 20' × 20'.

Photo by Glenn Hartong, CINCINNATI ENQUIRER

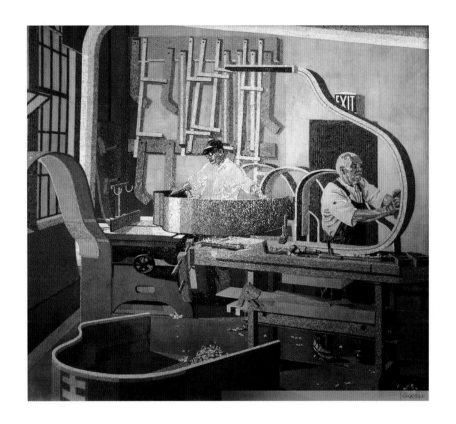

1.20. INDUSTRIAL/WORKER MURAL: BALDWIN PIANO,
1933.

Silhouette mosaic, 20' × 20'.

Photo by Glenn Hartong, CINCINNATI ENQUIRER

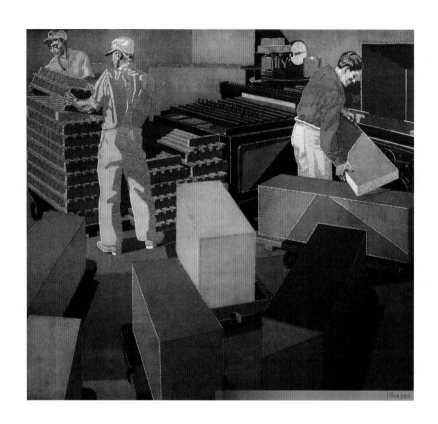

1.21. INDUSTRIAL/WORKER MURAL: PROCTER AND
GAMBLE (SOAP MANUFACTURE), 1933.

Silhouette mosaic, 20' × 20'.

Photo by Glenn Hartong, CINCINNATI ENQUIRER

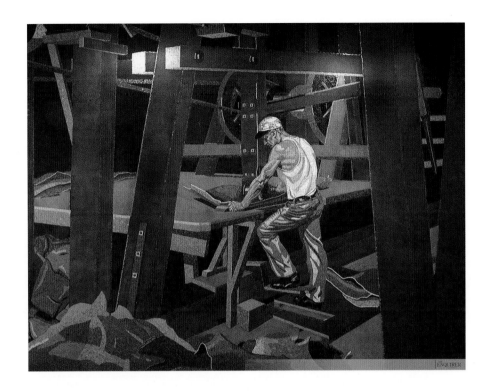

1.22. INDUSTRIAL/WORKER MURAL: AMERICAN OAK
LEATHER, 1933.

Silhouette mosaic, 20' × 20'.

Photo by Glenn Hartong, CINCINNATI ENQUIRER

1.23. INDUSTRIAL/WORKER MURAL: ROOKWOOD POTTERY, 1933.

Silhouette mosaics, each 10' × 20'.

Photos by Glenn Hartong, CINCINNATI ENQUIRER

SAVING THE TERMINAL

I N 1972–73 A "Save the Terminal Task Force" was appointed by Mayor Thomas Luken when it appeared that the concourse would have to be taken down. The chairman of the committee was Alfred Moore. The Ravenna Mosaic Company (which had created the murals) consulted with the task force and recommended that the industrial panels could be moved, or else recreated.

Initially, Professor Gabriel Weisberg of the University of Cincinnati (whose art history graduate students were hard at work on research about the terminal) had a radical idea. In a letter to Arno Heuduck of the Ravenna Company, he suggested that the concourse might be raised by five feet, thus leaving the concourse murals in place.[40] This proved impossible, thus leaving Ravenna's suggestion that they reproduce the panels, and Heuduck supplied an estimate of the replacement costs.[41] Fortunately, that was not necessary, because it was discovered that the panels were not adhered to the underlying brick wall but to a "hollow" wall of firebrick. It turned out that the panels could be separated whole from that hollow wall, which they were, and then moved to the airport intact. Still, this was a huge engineering feat, as each 20' × 20' panel weighs eight tons and they were shipped crated, but standing upright.[42]

The Detzel Construction Company and the Fenton Rigging Company were in charge of the removal to the Cincinnati/Northern Kentucky International Airport. The removal process was complex but successful. The murals were cleaned and installed in the airport, where they have been on view since the move.[43] Some

enthusiasts have been thrilled to find them at ground level and not high on the wall as they were at the terminal.

At the time of this writing, however, only five of the murals are viewable, because of planned demolition at the airport. In 2013 another "Save the Murals" movement got under way, and many hope to bring either the nine murals no longer on view, or all of them, back to Cincinnati. Then-mayor Mark Mallory began a campaign to raise the $5–7 million it would cost to "Bring the murals back home to Cincinnati." He saw the best future home as the city-owned convention center.[44]

In 2013, journalist Cliff Radel of the *Cincinnati Enquirer* began a string of articles on the issue of removing—yet again—the industrial/worker mosaics and finding a new home for them. He has also reached out to his readership to identify individuals depicted in the murals. Several have been identified, thus making the issue of the murals one in which the readers of the *Enquirer* are invested.

Despite the loss of the concourse, the heroic "Save the Terminal" community effort did save the rest of the terminal after it was shut down for passenger traffic. After being a shopping mall for a while, it was eventually transformed (beginning in 1990) into the Cincinnati Museum Center, where it currently houses the Cincinnati History Museum, the Cincinnati History Library and Archives, as well as the Duke Energy Children's Museum and an OMNIMAX® Theater. A combination of Hamilton County bond sales and funding from corporations, foundations, and individuals paid for the renovations. Happily, Reiss's murals in the rotunda were refurbished and continue in their brilliant glory.

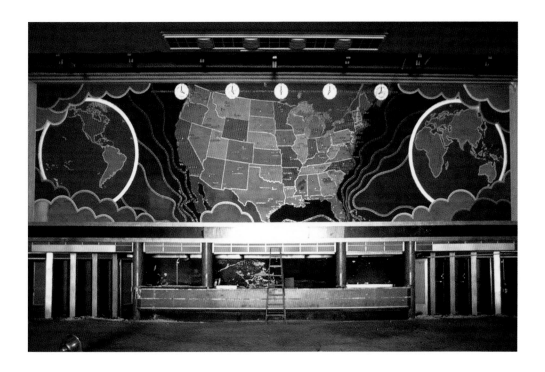

1.24. MAP MOSAIC AT THE END OF THE CONCOURSE, 1933.

States are not named, only cities that had train terminals. The photo was taken in 1972, when the demolition of the concourse had already begun.

Photo by Gregory Thorp

PART
TWO

THE ARTIST

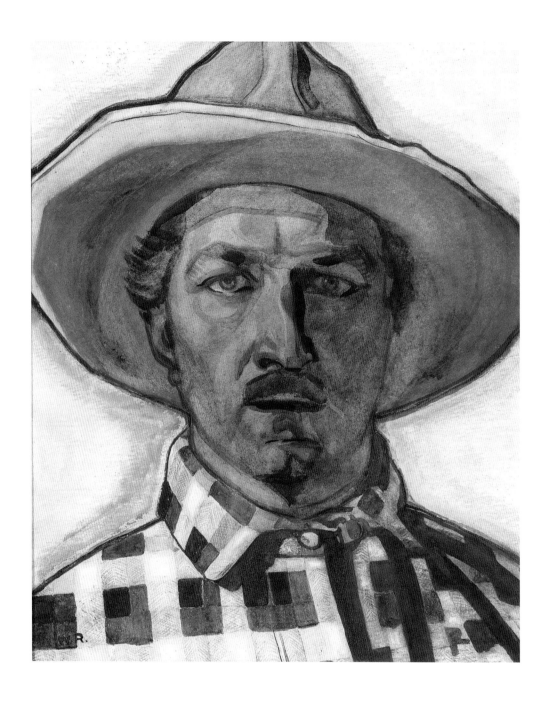

2.1. WINOLD REISS, **SELF-PORTRAIT**, 1919.

Mixed media, 17" × 14".

Bradford Brinton Memorial Collection at the Brinton Museum in Big Horn, Wyoming

WINOLD REISS

BORN IN Karlsruhe, Germany, in 1886, Fritz Winold Reiss was an immigrant to the United States, arriving October 29, 1913. A superbly gifted painter and designer, Reiss came to the United States after training from his father, Fritz Reiss, and later in Munich from Franz von Stuck at the Kunstakademie and Julius Diez at the Kunstgewerbeschule.[1] The intention of the modern German movement was to break down divisions between the fine arts and interior decoration. Bold and brilliant colors were favored, so Reiss arrived in New York with advanced knowledge and skill in contemporary design and color theory, as well as impressive accomplishments in portraiture. After Winold's voyage, his young wife Henriette and infant son Tjark left Germany for the United States as well.

We know that as a young European immigrant Reiss was already familiar with stories of the West by James Fenimore Cooper and Karl May, and he had probably seen some of the "Wild West" shows that were very popular in Germany in his youth. Reiss was eager to paint Indians when he arrived in the United States, but unfortunately he did not find them in New York City! With Henriette and his little son to support, he turned to design commissions, where he was both in the avant garde and successful. The Crillon, Longchamps, Alamac, and St. George Hotel restaurants were major commissions, among many others. Reiss designed everything from the business cards to the furniture, lighting, and murals. Graphic design and illustration for a number of other clients kept him busy. (Along the way, he was inspired by the Indian dress and beadwork he found at the American Museum of

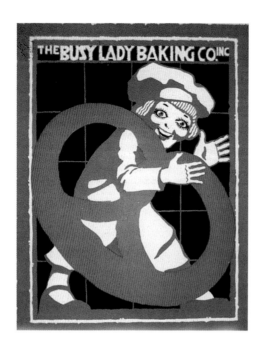

2.2. WINOLD REISS, INSERT IN
MODERN ART COLLECTOR (M.A.C.)
NO. 2, AD FOR THE BUSY LADY
BAKERY, 1915.

12" × 9¹/₄".

Reiss Archives

2.3. WINOLD REISS, FIRST COVER
OF **MODERN ART COLLECTOR
(M.A.C.)**, 1915.

12¹/₄" × 9¹/₂".

Reiss Archives

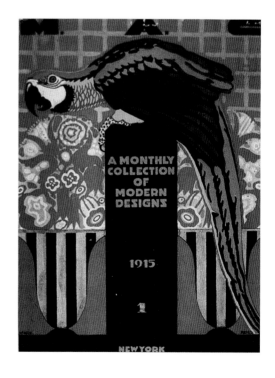

Natural History. When Reiss did find an Indian in the New York subway—he was hungover, and had just been fired by a circus—Reiss dressed him in costumes borrowed from the museum and posed him for a portrait.[2])

Reiss became famous also for his distinctive lettering, with its forward-leaning *s*. In his design work, as C. Ford Peatross has pointed out, he was known for brilliant color, modern geometric forms (chevrons, scallops, wavy stripes), and very early he was interested in design concepts from primitive or folk cultures.[3] In addition to his design commissions, Reiss was a founder of *Modern Art Collector (M.A.C.)*, first published in 1915, a journal that brought modern design concepts to New York.

Besides his own design, editorial, and portrait work, Reiss was a popular and committed teacher. He opened his own art school in Manhattan in 1915. In 1920 he would open a summer art school in Woodstock, New York, and, from 1934 to 1937, a summer school in Glacier Park, Montana. Every year from 1916 to 1919 and 1924 to 1929, Reiss taught at the New York School of Applied Design for Women (which would later become a part of the Pratt Institute). After the completion of the Cincinnati Union Terminal murals, he was offered a position as assistant professor of mural painting at New York University, where he taught until 1941. A busy artist indeed.

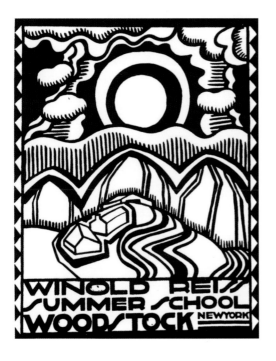

2.4. WINOLD REISS, BROCHURE FOR THE WOODSTOCK SUMMER SCHOOL, 1919.

$6^{1}/_{4}" \times 4^{3}/_{4}"$.

Reiss Archives

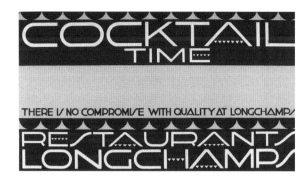

2.5. WINOLD REISS, LOBBY CARD FOR LONGCHAMPS
RESTAURANTS, CA. 1935–45.

Library of Congress

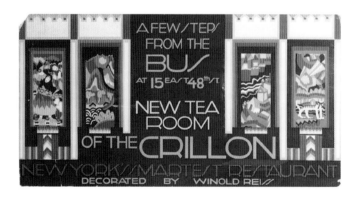

2.6. WINOLD REISS, BUS CARD ADVERTISEMENT FOR
THE CRILLON RESTAURANT.

13" × 21¹/₂".

Reiss Archives

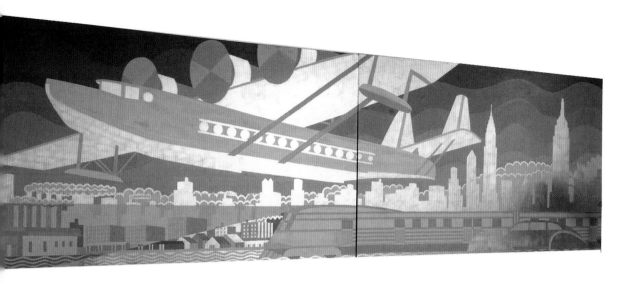

2.7. WINOLD REISS, **RACE BETWEEN AN AEROPLANE, EXPRESS TRAIN AND A MOTOR-CAR**, PART OF **CITY OF THE FUTURE**, CA. 1936.

Oil on canvas mural, 58" × 104", Longchamps Restaurant, New York.

George Schwarz Collection, New York

After his big Cincinnati commission, Reiss continued to create murals, many of them for restaurants, including five locations of Longchamps restaurants in New York and one in Washington, DC. Other clients included the Steuben Tavern in New York, the Hess Brothers Department Store in Allentown, Pennsylvania, the Theater and Concert Building at the 1939 New York World's Fair, the Woolaroc Museum in Bartlesville, Oklahoma, and the Santa Fe Railroad ticket office in Kansas City, Missouri.[4] Some of these projects included mosaic elements, but none on the scale of the Cincinnati Union Terminal.

The themes of his painted murals before and after Cincinnati were often historical, or sometimes exotic/tropical, but one standout was the murals for the Longchamps restaurant at 1450 Broadway. Here the theme was the "City of the Future," and it allowed Reiss to pick up the transportation theme that was so important in the Cincinnati work. Most exciting was the big (58" × 184") wall that showed *Race between an Aeroplane, Express Train, and a Motor-car*, dated 1936. The blues and gold of this mural also echo the blues and silver of the sky of the Cincinnati murals.

Along with his abstract design work, illustration, murals, and teaching, with training from his father, Fritz Reiss, Winold was a consummate realistic portrait artist. He completed many portrait commissions as well as self-initiated portraits on his travels to Montana, Mexico, Europe, and St. Helena Island, South Carolina.[5] Reiss showed his work extensively in galleries and museums from 1920 on, his Indian portraits being his most popular. A large number of his portraits were made in pastel, or pastel and crayon with tempera. He had a style all his own of completely finishing the faces and hands, with incredible modeling, but leaving the clothing blank or less finished. His technique was taught to his students:

> He was very particular. We had to draw lifesize. He insisted that we go up to the model and measure the features, press the facial bone, with our hands, in order to learn the proportions. He brought all of that German precision to his portraits, and he demanded it of his students.[6]

Reiss made portraits that were realistic, but also beautiful as works of art—and also, as sculptor Isamu Noguchi (one of his subjects) once remarked, flattering.

FACING PAGE:

2.8. WINOLD REISS, **ISAMU NOGUCHI**, 1929.

Pastel, 29" × 21$^1/_2$".

National Portrait Gallery, Smithsonian Institution / Art Resource, New York

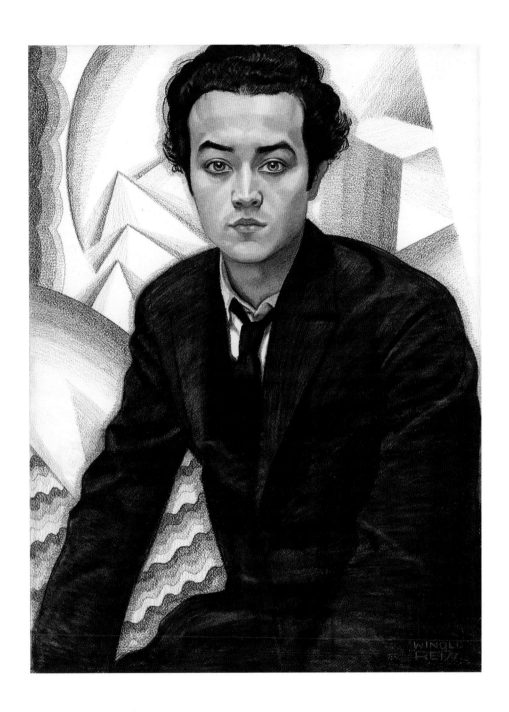

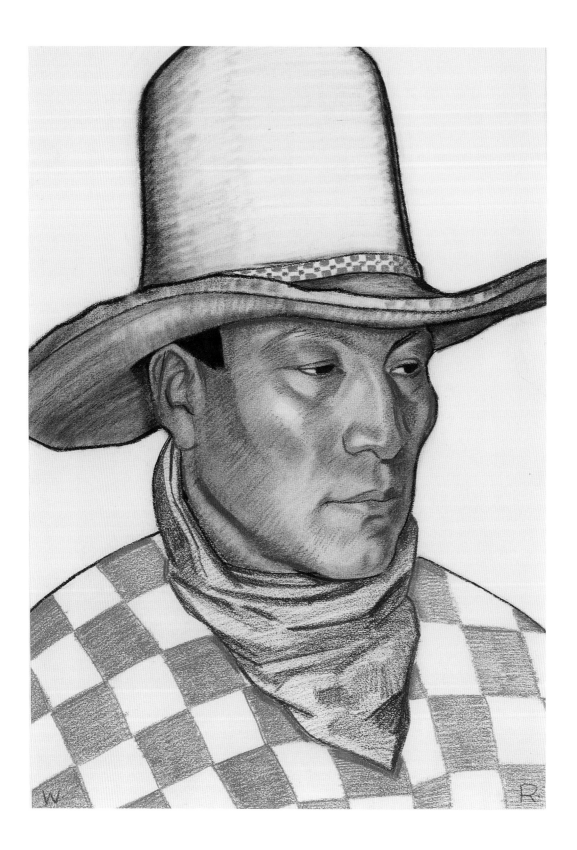

INDIANS

R EISS WAS FINALLY able to make his first trip to Montana on January 5, 1920. Soon after he arrived he began a series of portraits of Blackfoot Indians that spanned a number of years. He made friends and admirers in the tribe, which made him an honorary member, giving him the name Beaver Child as a tribute to his productivity. In his first visit to the Blackfoot, during a few weeks from January to February 1920, he produced 35 Indian portraits.[7]

FACING PAGE:

2.9. WINOLD REISS, **ARROW TOP**, 1920.

Charcoal, conté pencil, and colored pencil, $19^1/_2$" × $13^5/_8$".

Bradford Brinton Memorial Collection at the Brinton Museum in Big Horn, Wyoming

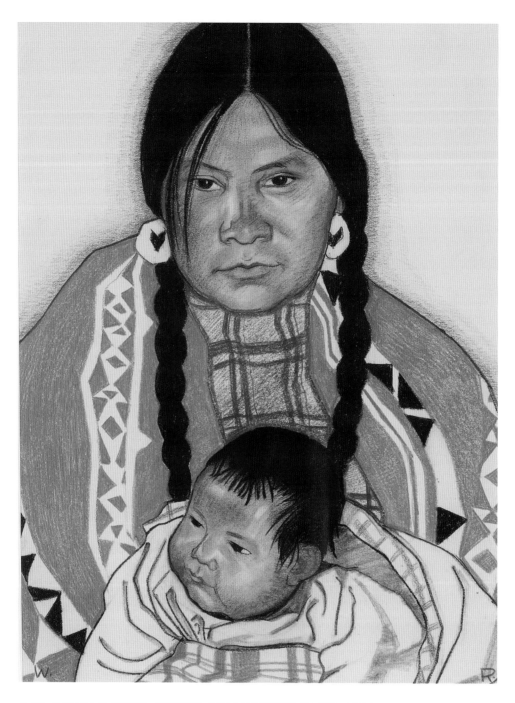

2.10. WINOLD REISS, **BERRY WOMAN WITH BABY**, 1920.

Crayon, 19 $^5/_8$" × 14 $^5/_8$".

Bradford Brinton Memorial Collection at the Brinton Museum in Big Horn, Wyoming

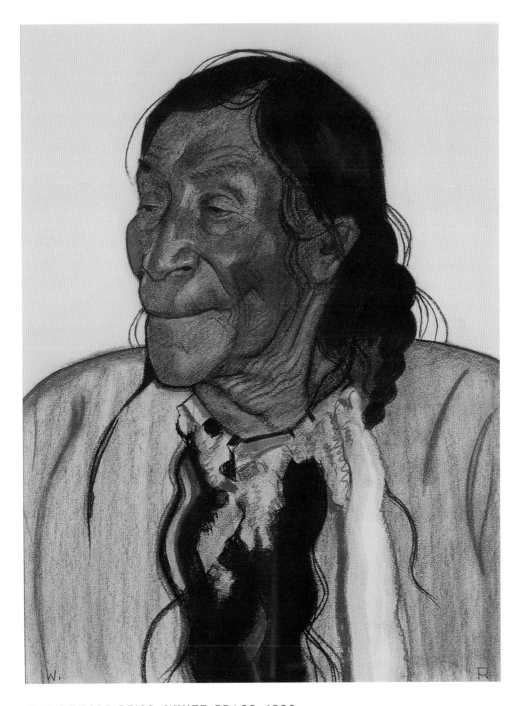

2.11. WINOLD REISS, **WHITE GRASS**, 1920.

Colored pencil, 19 $^5/_8$" × 14 $^5/_8$".

Bradford Brinton Memorial Collection at the Brinton Museum in Big Horn, Wyoming

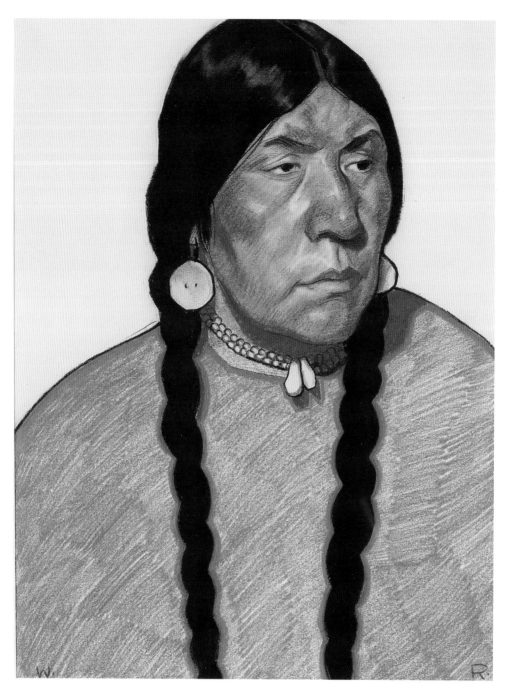

2.12. WINOLD REISS, **COMES BACK**, 1920.

Crayon, $19^5/_8$" × $14^5/_8$".

Bradford Brinton Memorial Collection at the Brinton Museum in Big Horn, Wyoming

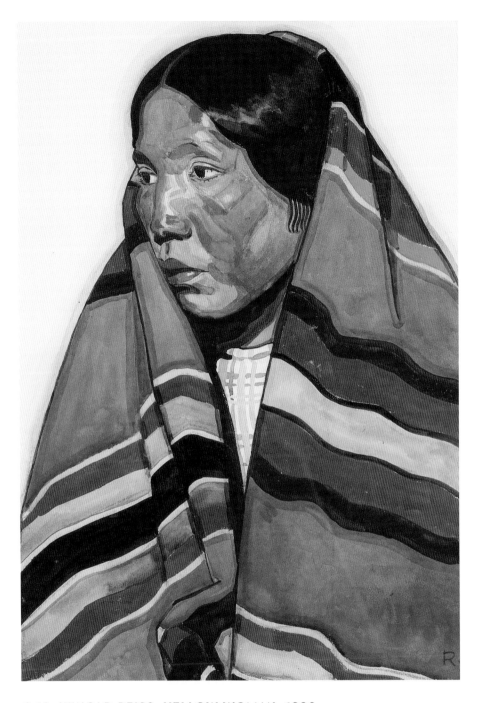

2.13. WINOLD REISS, **YELLOW WOMAN**, 1920.

Watercolor, $19^5/_8$" × $14^5/_8$".

Bradford Brinton Memorial Collection at the Brinton Museum in Big Horn, Wyoming

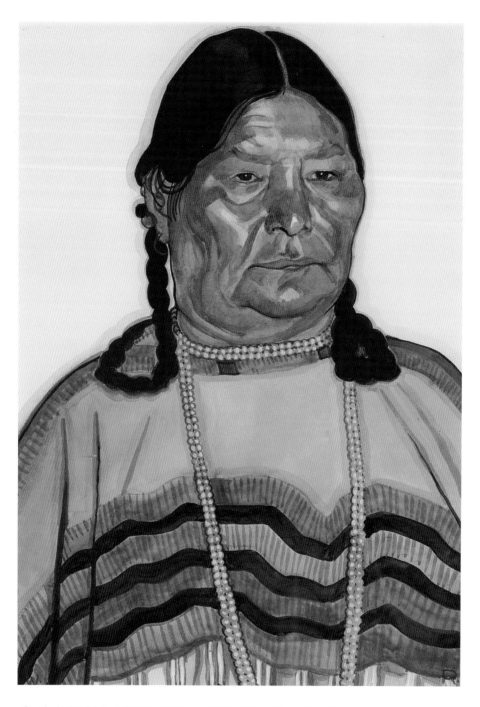

2.14. WINOLD REISS, **FINE VICTORY WOMAN**, 1920.

Watercolor, 19$\frac{5}{8}$" × 14$\frac{5}{8}$".

Bradford Brinton Memorial Collection at the Brinton Museum in Big Horn, Wyoming

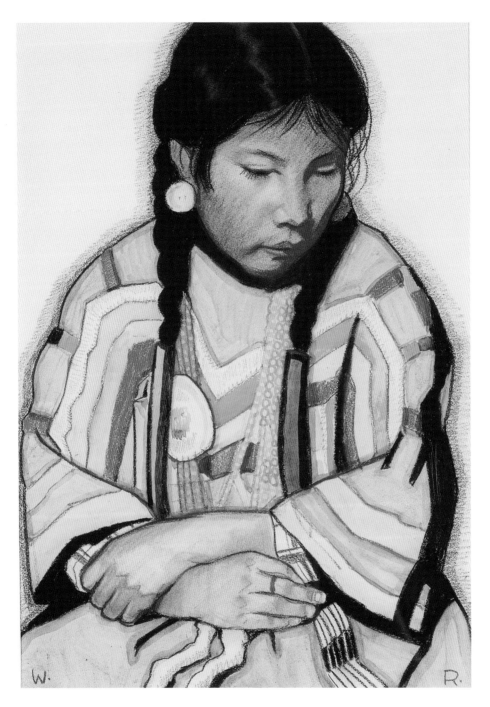

2.15. WINOLD REISS, **MEDICINE OTTER WOMAN**, 1920.

Crayon and watercolor, 19 $^5/_8$" × 14 $^5/_8$".

Bradford Brinton Memorial Collection at the Brinton Museum in Big Horn, Wyoming

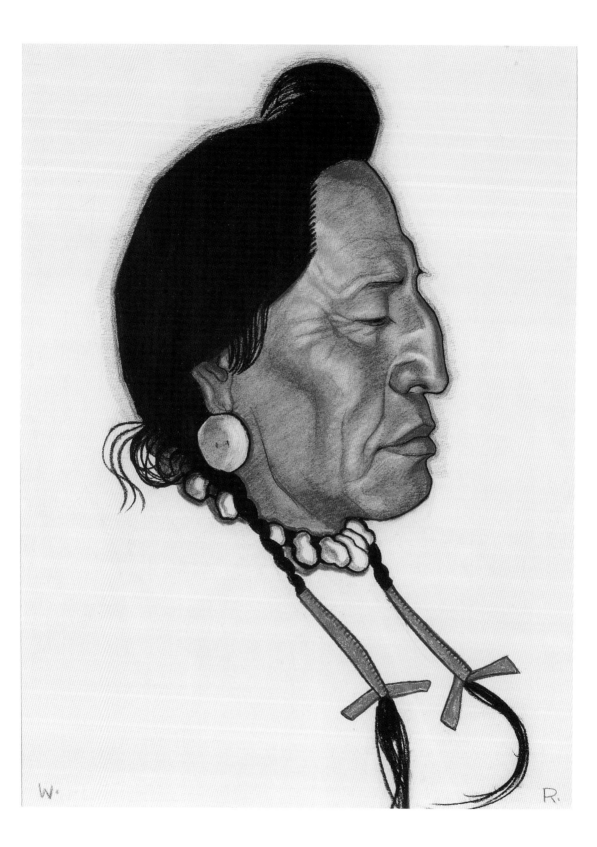

2.16. WINOLD REISS, **TWO GUNS WHITE CALF**, 1920.

Crayon, 19$^3/_4$" × 13$^3/_4$".

Bradford Brinton Memorial Collection at the Brinton Museum in Big Horn, Wyoming

Winold Reiss was not the first Eastern or European artist to be attracted to Indians as subjects, of course. In the nineteenth century George Catlin, Karl Bodmer, and Eastman Johnson made meticulous and fascinating records of the Western and Northern Indians. In the early twentieth century a group of transplants, the Taos [New Mexico] Society of Artists, active from 1898 to 1927, concentrated on the Pueblo and Navajo Indians of the Southwest. A later Santa Fe group, the Cinco Pintores, continued this work. Without going too far afield, a useful comparison can be made between Reiss and the Taos painter E. Martin Hennings, his closest contemporary among the Southwest group. Hennings and Reiss were not only born in the same year; at just about the time Reiss was emigrating to the United States (1913), Hennings was crossing the ocean in the other direction to study with Franz von Stuck at the Kunstakademie in Munich—where Reiss had also studied.

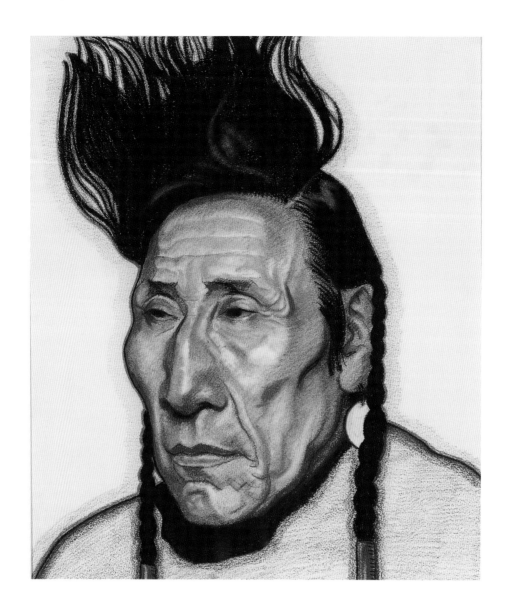

2.17. WINOLD REISS, **TURTLE** (VERSION 1), 1920.

Crayon, $19^{3}/_{4}$" × $14^{1}/_{4}$".

Bradford Brinton Memorial Collection at the Brinton Museum in Big Horn, Wyoming

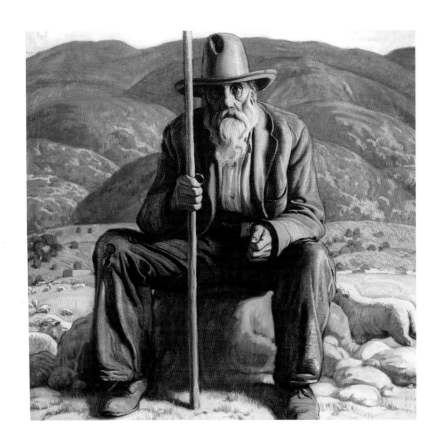

2.18. E. MARTIN HENNINGS, **THE SHEEPHERDER**, N.D.

Oil on canvas, 40" × 40".

Private collection

Both artists were fascinated with Indians , but there were differences. Reiss focused intensely on the individual face and did not include realistic settings in his portraits, whereas *place* as such—the pueblos, the ceremonies, the aspens, the mountains, the Grand Canyon, the weather even—were of equal interest to Taos artists like Hennings. In general, Hennings's subjects were depicted doing something, or at least as part of their surroundings, not just posing for the artist as in Reiss's portraits. While the Southwest transplants (they were all from somewhere else) had a romantic view of the Indians and of Indian life, Reiss seemed to want simply to probe into their individuality, one by one. The Southwest artists generally worked in oils, in a painterly style, whereas Reiss preferred pastels and tempera, and his portraits, with their definitive outlines and sculptural modeling, were much more linear in style. He loved, as well, the patterns he found in the clothing.

FACING PAGE:

2.19. WINOLD REISS, **LAZY BOY IN HIS MEDICINE ROBES**, 1927.

Pastel and tempera, 44" × 30$\frac{1}{2}$".

Department of Anthropology, National Museum of Natural History, Smithsonian Institution

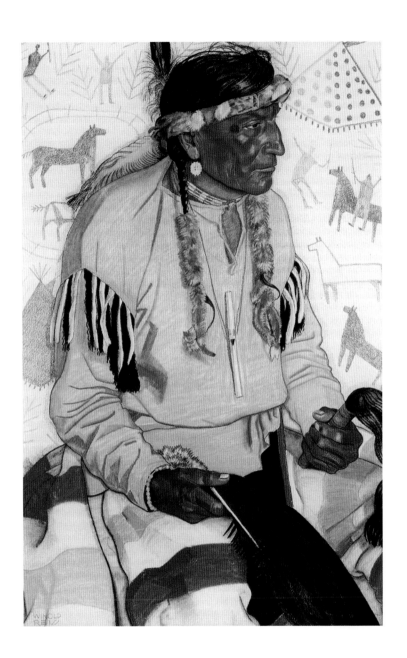

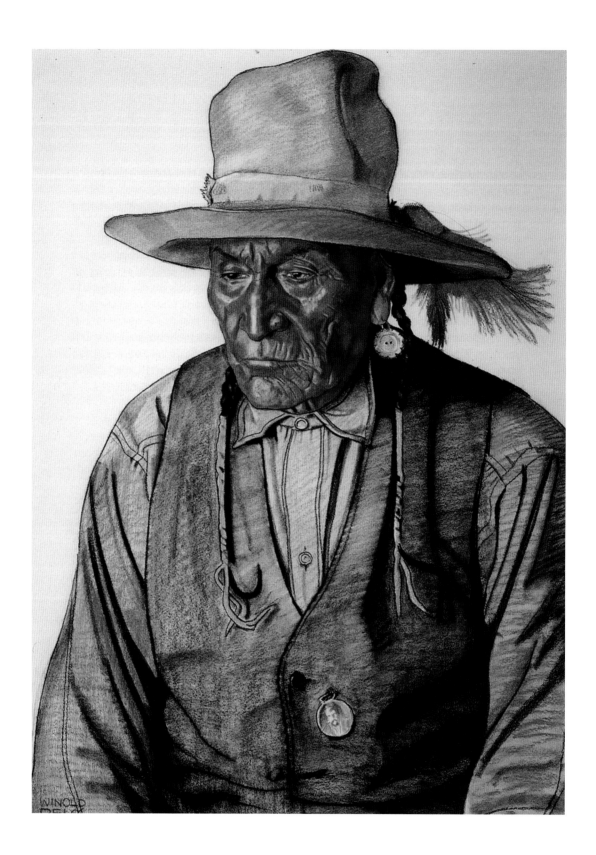

2.20. WINOLD REISS, **LAZY BOY IN EVERYDAY CLOTHES**, 1927.

Pastel, 29$^1/_2$" × 21$^1/_2$".

Private collection

Reiss continued to explore. After his 1920 trip to Montana, a trip to Mexico followed later that year, resulting in a body of portraits of the Mexican Indians Reiss admired there. Some of his Mexican scenes would be included in a 1924 number of *Survey Graphic*, edited by Katherine Anne Porter and focused on Mexico. Reiss's only return visit to Europe, from September 1921 to May 1922, resulted in a series of peasant portraits from Germany and Sweden. Reiss was especially interested in the passion play staged at Oberammergau every ten years, and he made several portraits of the actors. The *Century Magazine* published nine of these portraits, along with an essay by Reiss.[8] He called it "one of the few spots in all the world where faith and idealism have successfully withstood materialism and commercial greed."[9]

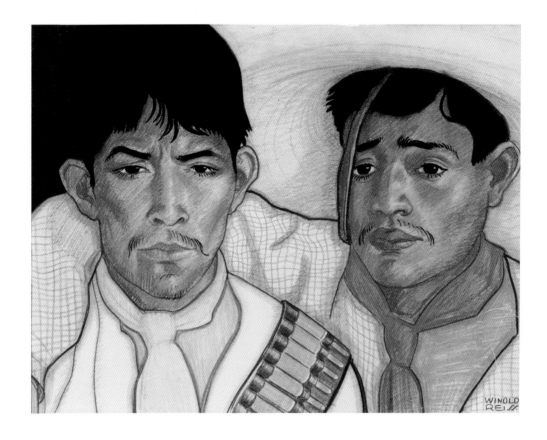

2.21. WINOLD REISS, **ZAPATISTA SOLDIERS**, 1920.

Pastel, 15" × 19^3/$_4$".

Private collection, image courtesy Reiss Archives

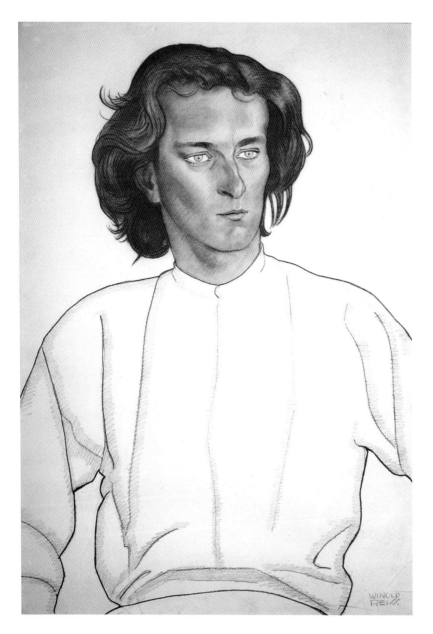

2.22. WINOLD REISS, OBERAMMERGAU, **MELCHIOR BREITSAMTER, JOHN**, 1922.

Conté pencil and colored pencil, $28^1/_2$" × $19^3/_4$".

Private collection, image courtesy Reiss Archives

An important later commission from Alain Locke, guest editor of *Survey Graphic*, resulted in a series of portraits of Harlem Renaissance figures, published in 1925, that brought Reiss his greatest renown. The publication was the March 1925 issue of *Survey Graphic*, titled "Harlem: Mecca of the New Negro." There is a group of twelve of these Harlem portraits in the National Portrait Gallery. Others are in the collection of Fisk University in Nashville. Reiss also made a series of portraits of Asian Americans in 1926 for *Survey Graphic*, as well as of African Americans living on St. Helena, a sea island in Beaufort County, South Carolina, in 1927—many now in the Fisk University Galleries. In 1942, Reiss joined with Locke in producing another issue of *Survey Graphic*, "Color: The Unfinished Business of Democracy." Reiss's work appeared in *Survey Graphic* in 1924, 1925, 1926, 1929, 1936, 1941, 1942, and 1945.[10]

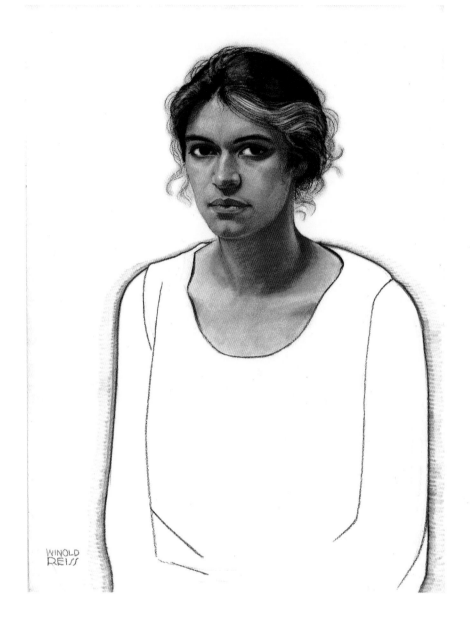

2.23. WINOLD REISS, **ELISE MCDOUGALD**, 1924.

Pastel, 30 $^1/_{16}$" × 21 $^9/_{16}$". Reproduced in the March 1925 SURVEY GRAPHIC.

National Portrait Gallery, Smithsonian Institution / Art Resource, New York

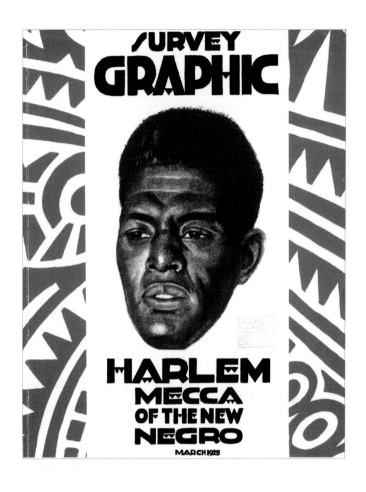

2.24. WINOLD REISS, **ROLAND HAYES**, 1924.

Cover of the March 1925 SURVEY GRAPHIC.

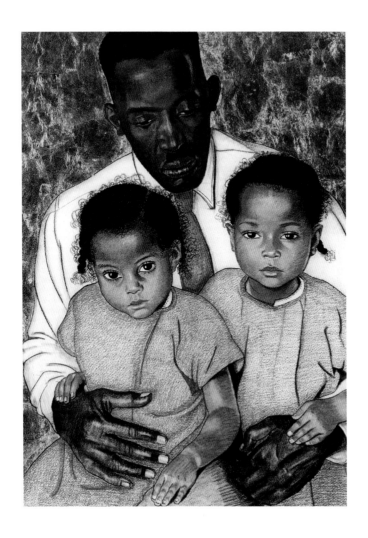

2.25. WINOLD REISS, **FATHER (FRED FRIPP) AND
TWO CHILDREN**, 1927.

Pastel and gold leaf, 30" × 22$\frac{1}{2}$".

Fisk University Galleries

TYPES

APART FROM HIS commissioned portraits or portraits of friends, Reiss chose to concentrate on subjects who were less recognized, less valued, in contemporary culture—Blackfoot and other Plains Indians, African Americans, Mexican Indians (not Spanish Mexicans), and, back in Europe, peasants. As historian Jeffrey C. Stewart has said, Reiss "bonded with a series of communities" and "found a spiritual home there."[11] He sincerely admired and sympathized with all these indigenous people, and his every portrait expressed great and dignified beauty, no matter how old, or wrinkled, or poor the individual.

The Cincinnati murals were a culmination of Reiss's broad interest in and depiction of many kinds of Americans. In the murals he included several American "types" without featuring—at least in his compositional scheme—any one as being of greater importance or fame. None of the rotunda figures is a city man, or, aside from the riverboat captain, anyone who could be perceived as a boss. No figure is larger in stature than any other. This absence of hierarchical distinction expressed his deepest beliefs. My subtitle, "Fanfare for the Common Man," seems just right for Reiss's heartfelt celebration of ordinary Americans in the rotunda mosaics, as well as the workers in the industrial panels in the concourse. Of course, it was also the title of Aaron Copland's stirring brass piece of 1942, which he wrote, as it happens, for the Cincinnati Symphony Orchestra.

In 1942 Copland was commissioned—along with sixteen others—by Eugene Goossens, conductor of the Cincinnati Orchestra, to compose a "fanfare." This

form of ceremonial music was traditionally meant to herald the arrival of a great man. Goossens instead wanted to honor the Allied Forces in the war. Aaron Copland responded with the splendid *Fanfare for the Common Man*. As critic Sean Wilentz has written, Copland's *Fanfare* "can be understood as a coda to *Lincoln Portrait*, which Copland completed only a few months earlier" (also for Cincinnati), and can be understood as heralding "the noble groundlings, grunts, and ordinary men—not just their service and sacrifice in the war, but their very existence and their arrival in history."[12] As Wilentz describes the Copland piece, it bears an uncanny likeness to the feeling of Reiss's mosaics:

> Copland's *Fanfare* . . . is stately and deliberate, perhaps the most austere fanfare ever written. Beginning with its opening crash and rumble, it builds slowly in sonority and complexity, moving by stages from dark, obscure tones to an almost metallic brilliance, soaring and then concluding with a bang, in a different key from where it began. In its dignified simplicity, it is also complex—a subtly esoteric piece of music written for the democratic masses as well as to honor them. . . . Simplifying music, Copland believed, need not mean cheapening it; it could, in fact, help form the basis of an American artistic style that would fuse "high," "middle," and "low," elevating creatively interesting forms of popular culture while also popularizing more serious culture.[13]

While Reiss and Copland did not share the same political history, exactly, they both had profound sympathies with, as Copland put it, "the common man." Jeffrey Stewart has written that Reiss subscribed to the "nineteenth century belief that the world was divided into distinct races or 'types,' each of which possessed special cultural attributes. By documenting all of the varieties, Reiss hoped to produce a comprehensive record of the races that would form a collective portrait of humanity. He believed that by showing the honor, beauty, and dignity of all peoples, his art would break down racial prejudice and testify to what Johann Wolfgang von Goethe called the 'unity of all creation.'"[14] The broad expanses in the rotunda offered a rich opportunity to put his beliefs into practice by creating a panorama of American types. Not all the racial variety of the country was included, but the murals followed Reiss's interest in American Indians, African Americans, and the white settlers who helped make up the United States.

A similar but even broader contemporary project was undertaken by sculptor Malvina Hoffman, who was commissioned by Stanley Field, director of the Field Museum of Natural History in Chicago, to travel the world and create sculptures of all the racial types of humanity. Hoffman's many sculptures representing diverse groups of humans in cultures around the world became an exhibition at the museum called *Hall of the Races of Mankind*, or *Hall of Man*. Her series of 105 figures was begun in 1930 and finished in 1933, coincident with Reiss's work in Cincinnati. It was popular with visitors, but three decades later the focus on "race" began to be questioned and the sculptures were dispersed around the museum.[15]

2.27. MALVINA HOFFMAN, **BLACKFOOT INDIAN**, 1933.

Bronze sculpture, life size. Hall of Man, Field Museum of Natural History, Chicago. The gesture means, "I have seen my enemy and killed him."

© Field Museum, CSA77747, photographer Charles Carpenter

Two photographers contemporary with Reiss were also intensively engaged in the portrayal of types. One was his fellow German, August Sander, whose vast project was called *People of the 20th Century*. Sander believed in revelation by physiognomy, and he let pose and dress speak for character. Begun in 1911, the project was partially published under the title *Face of our Time* in 1929, but after that Sander was greatly constrained by the Nazi regime, and in 1936 the plates for the book were seized and destroyed. Thirty-eight years after his death in 1964, Sander's work finally received full publication.[16] His simple and direct portraits record class and occupational differences, although only occasional differences of race. (It is interesting that Sander also used the leaning *s* in his graphic design, just like Reiss.)

PAGES 88–89:

2.28. ADVERTISING POSTER FOR AUGUST SANDER, SHOWING SELF-PORTRAIT SILHOUETTE AND LEANING **S**, 1926.

2.29. AUGUST SANDER, **BOXERS**, 1929.

DEUTSCHE PHOTOGRAPHISCHE AUSSTELLUNG

IN FRANKFURT a.M. 1926
IM HAUSE WERKBUND

VERANSTALTET VON DER MESSE-UND AUSSTELLUNGSGESELLSCHAFT
M B H IN VERBINDUNG MIT DEM CENTRALVERBAND (REICHSVERBAND)
DEUTSCHER PHOTOGRAPHEN VEREINE UND INNUNGEN. E V
EINTRITT .M BESUCHSZEIT

2.30. EDWARD S. CURTIS, **INDIAN PORTRAIT, LUMMI-TYPE.**

From THE NORTH AMERICAN INDIANS: A SELECTION OF PHOTOGRAPHS
BY EDWARD S. CURTIS

2.31. EDWARD S. CURTIS, **A TRAVOIS, BLACKFOOT.**

From THE NORTH AMERICAN INDIANS: A SELECTION OF PHOTOGRAPHS
BY EDWARD S. CURTIS

Another contemporary of Reiss who was avidly interested in American Indians
was photographer Edward S. Curtis of Seattle. His ambitious project to document
all the North American Indian tribes, which he considered to be a disappearing race,
was patronized by capitalist J. P. Morgan and President Theodore Roosevelt, as well
as others who subscribed to the publications of his photographs that appeared be-
tween 1906 and 1930. The twenty volumes of large photogravures of this work
were a document for the ages, and his prints are still collectors' items. Curtis has
come under criticism for removing signs of contemporary life in his Indian pictures
and dressing up his subjects in ceremonial clothes that did not even belong to them.
In truth, Reiss did the same thing, at least with his Indian subjects.

When Reiss first went to Montana, and as he continued to work there for many years, he portrayed Indians who literally had been dressed up to pose for tourists at the train station in Glacier Park. His great patron turned out to be Louis Hill, president of the Great Northern Railway and an early collector of his Indian portraits. (Louis was the son of James Hill, the founder of the Railway.) Reiss's history with the Great Northern began with obtaining access to the Indians who met the trains, and sales of many paintings of the Blackfoot for calendars.

In a similar way, several artists of the Taos School of Art created attractive images of Indians intended for popular advertisements, including work that was used for posters and calendars by the Santa Fe Railroad.

Reiss's calendars for the Great Northern Railway reproduced many of his best portraits. In 1928, eight of the monthly illustrations were by Reiss (the remainder were by his student, W. Langdon Kihn). In 1930 through 1933, all of the portraits were by Reiss.[17]

Later, Reiss's relationship with the Railway expanded to include permission and support to set up his school in Glacier Park from 1934 to 1937. From the Railway's perspective, Reiss was providing an appealing tourist attraction, with visitors allowed to peer in on the school and studios. Reiss and the students did not like these tourist interruptions, though, and after 1937 the school was discontinued. Still, Reiss continued to sell reproduction rights to his Blackfoot paintings to the Great Northern for calendars—but on a yearly, not monthly, basis.

FACING PAGE:

2.32. GREAT NORTHERN RAILWAY CALENDAR, ILLUSTRATED BY WINOLD REISS, NOVEMBER 1930.

22 $^{3}/_{8}$" × 10 $^{1}/_{4}$".

Wolfsonian-Florida International University, Miami Beach, Florida, Mitchell Wolfson, Jr., Collection

MANY MULES
GLACIER NATIONAL PARK

The RESERVE POWER *of* GIANT
OIL BURNING *and* ELECTRIC
LOCOMOTIVES IS A
COMFORT FACTOR
IN TRAVEL
On the
EMPIRE BUILDER
and the
ORIENTAL LIMITED

GREAT NORTHERN

1931	FEBRUARY					1931
SUN	MON	TUE	WED	THU	FRI	SAT
1	2	3	4	5	6	7
8	9	10	11	12	13	14
15	16	17	18	19	20	21
22	23	24	25	26	27	28

J. S. BOCK
General Agent
814 Old National Bank Bldg.

R. C. MURPHY
City Passenger and Ticket Agent
Davenport Hotel
SPOKANE, WASHINGTON

N. D. KELLER
City Passenger Agent
Davenport Hotel

IMAGINATIVES

I N HIS DECORATION work of the 1920s (and sometimes in portrait backgrounds), Reiss was fond of making what he called "imaginatives," abstract forms drawing often on African sources. Frankly, it can seem that Reiss is caricaturing the culture he admired so much. These designs can look awkward today, but to see them in a positive manner, they derived a great deal from the jazz rhythms of the time—and were often designed for restaurants and clubs where the most up-to-date music would be heard. The jagged forms and dizzy diagonals were synesthetic equivalents of the energy and new sounds of jazz. Later, he inserted "imaginatives" as backgrounds for his Indian portraits, but in that case they were drawn directly from Indian designs painted on teepees or other animal-hide paintings. For these, little in the way of abstraction was required on Reiss's part.

In the Cincinnati murals Reiss used imaginatives in another way. Two types of abstraction interweave in the background's blue "sky." These were the diagonal shafts, alternating between darker and lighter blue and grey tones, and also "clouds" of long, scallop-edged forms also alternating between lighter and darker blues, with gleaming silver edges. In among them floated depictions of the various forms of transportation—from dog-travois to paddlewheel steamer to locomotive to airplane —that had made settlement and trade possible in the huge country.

These abstract forms were a contemporary way of giving substance to ideas of energy and the forces of the universe. Other artists such as Charles Demuth and

2.33. WINOLD REISS, **DRAWING IN TWO COLORS (INTERPRETATION OF HARLEM JAZZ)**, 1915–20.

Lithograph.

Library of Congress

2.34. WINOLD REISS, **LANGSTON HUGHES**, 1925.

Pastel, 30 $^1/_{16}$" × 21 $^5/_8$".

National Portrait Gallery, Smithsonian Institution / Art Resource, New York

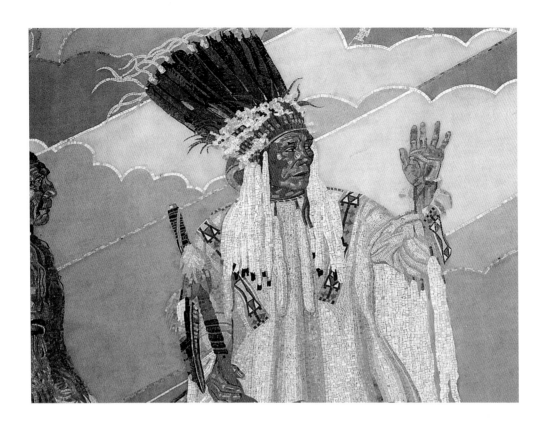

2.35. WINOLD REISS, DETAIL OF THE SOUTH MURAL SHOWING
IMAGINATIVES IN THE BACKGROUND, 1933.

Silhouette mosaic.

Photo by author

Elsie Driggs had been including what we might call abstract force-lines in their paintings in the twenties—partly suggesting pure energy, partly echoing the lines of the electric wires, steel cables, struts, and girders supporting modern industrial architecture. In fact, writing about the Elsie Driggs painting *Aeroplane*, art historian Theresa Carbone points out that "the spare network of ruled lines crosses the composition, suggesting air currents and constituting what was, by the late twenties, the obligatory formal attribute of refined industrial compositions."[18] It is no wonder that in a time of rapid social and technological change, a visual form suggesting change and force would become a popular motif. By the time Reiss used radiating lines in his work, they had become a design in the sky suggesting shafts of sunlight or perhaps even a spiritual radiation from the center of the murals. Remembering the original form of the terminal, the hallway that led from the center of the rotunda murals to the concourse itself was the pathway to the rest of the country, so perhaps this could be understood as the center of the radiance.

FACING PAGE:

2.36. CHARLES DEMUTH, **MY EGYPT**, 1927.

Oil and graphite pencil, 30" × 25³/₄".

Demuth Museum, Lancaster, Pennsylvania

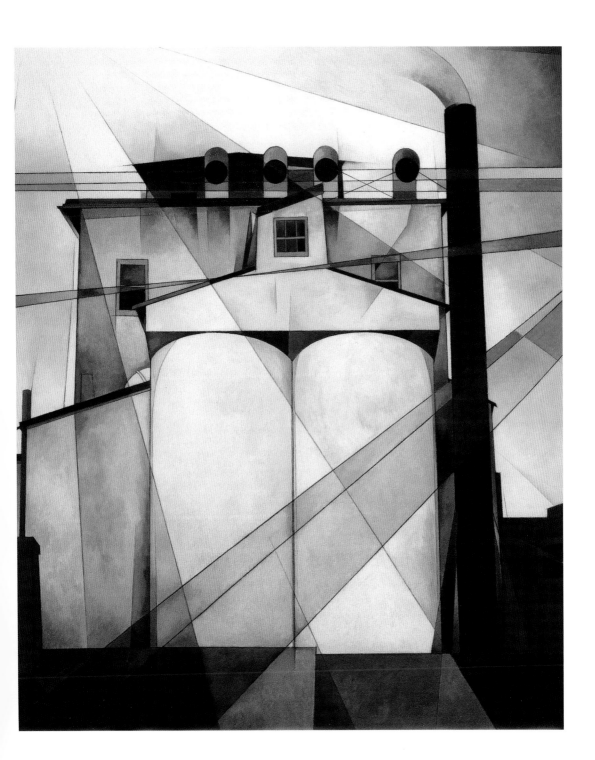

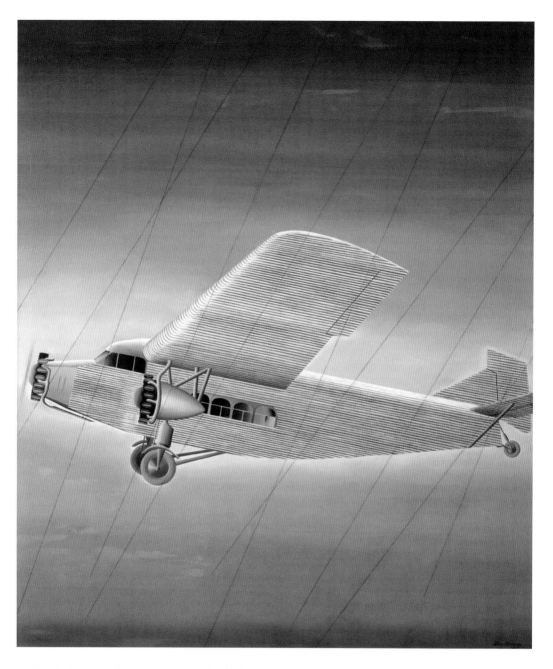

2.37. ELSIE DRIGGS, **AEROPLANE**, 1928.

Oil on canvas, 44" × 38".

Museum of Fine Arts, Houston / Merryman Gatch. Museum purchase funded by the Brown Foundation Accessions Endowment Fund

Winold Reiss was an enthusiastic American. By the time he became a citizen in 1932, as the Cincinnati project was under way, a positive, celebratory spirit imbued the vast panoramas. On March 30, he wrote to his son Tjark (whom he called Boyk or Boykie):

> Dear Boyk,
>
> Since quite a while I did not write. There are a lot of important news.
>
> First you have to congratulate me—I am now a newly baked citizen of the United States which makes you automatically the same. After long and hard fighting I am where I wanted to be 8 years ago.
>
> The first section of the mural is ready and shipped to Germany.[19] We are starting on the Cincinnati side.[20]

Unlike contemporary muralists Diego Rivera or Thomas Hart Benton, whose big wall-paintings depicted conflict and a kind of roiling, crowded, human scene, Reiss's stately line of Americans and radiating energy expressed dignity, each figure standing firmly—by himself or herself—on a special little bit of ground. Each character elicits the viewer's respect and sympathy, but certainly not political excitement. Perhaps this peaceful depiction is one reason that Reiss seems to have gotten lost in the footnotes of art history: not enough conflict or politics in his work. No headlines, no scandals, no fights. Another reason may have been Reiss's choice of the medium of mosaic for the work.

PART THREE

THE CONTEXT

MOSAICS

A MURAL IS A wall-painting, usually made in oil on canvas (later to be attached to the wall) or else in fresco, a type of stained plaster where the color is applied on wet plaster and imbues the very substance of the wall. Most murals of the twenties and thirties were paintings. But a *mosaic mural* is something else altogether, a glittering surface made by the labor-intensive method of applying tiny bits of colored glass (tesserae), in hundreds of different colors, to the wall to create the illusion, from a certain distance, of a sparkling, multihued painting. The glass bits are seen on the broken side (not flat), so have even more of a potential for brilliance.

A mosaic by tradition is used in a special space, often in a sacred setting, but Reiss had already used mosaic in some of his restaurant and commercial designs. He knew its dramatic effects, but when Reiss worked to convince his patrons in Cincinnati to use it he met with some resistance. The brilliance of mosaic was what he wanted, however, and he convinced them—even though he had to reduce his own commission to make the process affordable. On October 31, 1931, Winold wrote to his son:

> Back in New York again and in front of the closing for the Cincinnati Station. I think I get the other work too, the only disadvantage is that it is all going to Mosaic instead of painting. It has been a hard stand for me. The painting contract would have given me quite a nice profit whereas the mosaic will just pay living and working expenses. They asked me what I like better

and I advised Mosaic because on the long run it is a much finer material and more "*haltbar*" [enduring]. The Architeckts [*sic*] could not understand how I could kill a profitable commission but upon realization of my honest opinion in favor of the ultimate result I think they respect it now.[1]

He also proposed a new style, which he called "silhouette mosaic," that was actually something like a combination of mosaic with fresco. This technique had been worked out by Paul and Arno Heuduck of the Ravenna Mosaic Company. Ravenna had produced silhouette mosaic portraits of at least two of Reiss's Blackfoot friends—Sitting Bull and Mike Little Dog—as trial runs for the Cincinnati mosaics.[2] The figures, main pictorial features, and outlines would be in mosaic, with colored stucco filling in the rest of the spaces. Silhouette mosaic was less expensive than full mosaic would have been on the enormous walls of the terminal. Reiss provided, as examples of the technique he wanted to use in Cincinnati, two portraits of Mike Little Dog (dated 1930) that demonstrated clearly the silhouette technique: figures and pictorial elements in mosaic, background a neutral stucco.[3]

Mosaic requires the combined efforts of the artist/designer and the mosaic craftsmen. The artist prepares large working paintings (called cartoons), with broader areas of color than a customary painting would have, and the craftsmen, with great skill, translate each color into subtly varied areas of individual glass tesserae.[4] Reiss worked with the Ravenna Mosaic Company, already notable for many important commissions. The Ravenna company, named after the Italian city that had been the center of mosaic art for centuries, and with strong connections to Puhl & Wagner in Germany, was actually headquartered in New York, run by German immigrant Paul Heuduck and his son Arno. Eventually Ravenna Mosaic moved to St. Louis and provided the mosaics for the huge St. Louis Cathedral, the greatest installation of mosaic art in the world.[5]

The method that was used in Cincinnati is called the indirect or mirror method of construction. The gridded design was sized and reversed (back side to front) and cut into two-foot squares of paper. Then the tiles were glued onto the back side of the paper and, when the design was filled, applied to the wet plaster on the wall. When the plaster was dry, the paper could be soaked and removed, and then the front side of the mosaic revealed. After that the intervening areas were eventually scraped and filled with colored plaster.

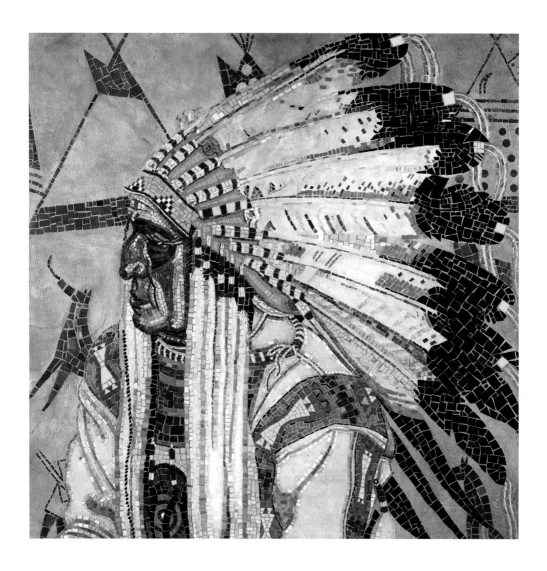

3.1. WINOLD REISS, **MIKE LITTLE DOG** (VERSION 2), 1919–30.

Silhouette mosaic, 57$^1/_2$" × 57$^1/_2$". This was fabricated by the Ravenna Mosaic Company for the Cincinnati Union Terminal competition.

Wolfsonian-Florida International University, Miami Beach, Florida, Mitchell Wolfson, Jr., Collection

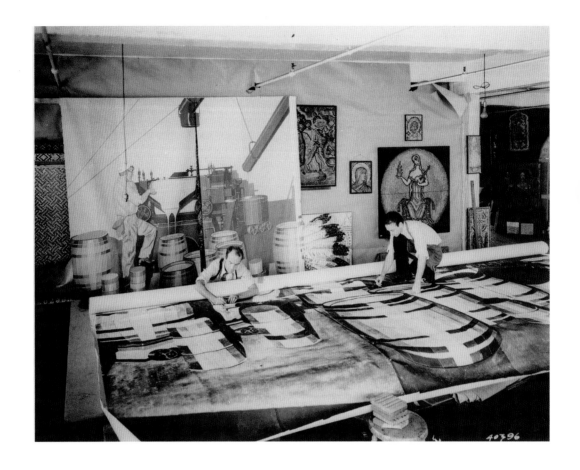

3.2. AT THE RAVENNA WORKSHOP: THE CRAFTSMEN ARE TRACING THE POSITIVE SIDE OF THE BLOWUPS OF ONE OF THE INDUSTRIAL/WORKER MURALS (REISS'S CARTOONS ARE IN THE BACKGROUND).

Cincinnati Museum Center Library and Archives (SC #20)

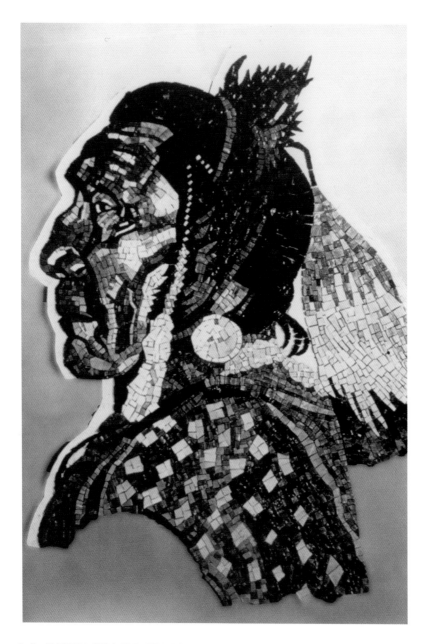

3.3. INTERMEDIATE STAGE, WHEN TESSERAE ARE APPLIED TO
THE BACK OF THE PAPER THAT WILL BE PRESSED INTO THE
PLASTER FOR THE FINAL MOSAIC.

Photo by Gregory Thorp, 1972

From the sheer labor involved, and the jewel-like results, it comes as no surprise that mosaic art was by tradition reserved for religious subjects. Although used as decoration for rich houses in the ancient world, from the fifth century onward most applications were in churches. In the twentieth century, however, a few notable secular mosaics began to be created. Among them were Winold Reiss's Cincinnati mosaics as well as his commercial designs for clients like the Longchamps restaurants (1935, 1936, 1938), the Woolaroc Museum in Bartlesville, Oklahoma (1946), and the Santa Fe Ticket Office, Kansas City, Missouri (1951).

Earlier in the century, Louis Comfort Tiffany—that great wizard of all kinds of glass art—had created some important historical and decorative mosaics that had no religious aspect. Most interesting in relation to Reiss, because they included Indians, Reiss's favorite subjects, were Tiffany's mosaics for the Marquette Building in Chicago (1897).[6] The scenes pictured by Tiffany showed important moments in Father Marquette's life, with full-length figures and the Indians in resplendent costume and headdresses.

Decades later, contemporary with Reiss, Hildreth Meière was another superb modernist who also worked in mosaic. Meière was a versatile artist whose work spanned religious and secular subjects. In 1932 she created a spectacular mosaic for the ceiling of the Walker-Lispenard Building in New York. This was the AT&T Long Distance Building and the mosaic has been titled *The Continents Linked by the Telephone and Wireless*. Four sections of the mural scheme were dedicated to four parts of the world: Australia, Asia, Africa, and Europe. Each is anchored by a reclining mythological figure and backed by a diagonal spray of gold mosaic lines to represent the lines of telecommunication. This mural was constructed by the same Ravenna Company that did Reiss's murals in Cincinnati, and it was rendered in Ravenna's specialty method, silhouette mosaic, also used by Reiss.

As it happened, another contemporary patron of mosaics was Joseph Stalin in the Soviet Union. The great and splendid Moscow subway system was begun under his direction in 1935. The subways were built as gorgeous underground palaces for the people, and many of the stations are decorated with multiple mosaics—purely secular, unless Communism could be considered a religion. For example, the mosaic scenes in the Kievskaya Station (1954) all depict happy scenes usually involving children or women handing bouquets to Soviet leaders or soldiers, with the Soviet flag waving in the background. More interesting are the oval ceiling mosaics in the

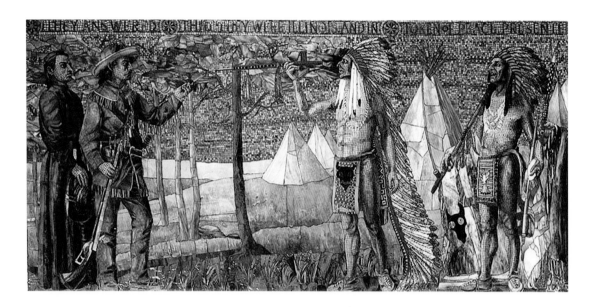

3.4. LOUIS COMFORT TIFFANY AND J. A. HOLZER, PÈRE MARQUETTE
MOSAICS IN THE MARQUETTE BUILDING, CHICAGO (DETAIL), 1897.

John D. and Catherine T. MacArthur Foundation

3.5. HILDRETH MEIÈRE, "AFRICA," DETAIL OF THE LOBBY CEILING OF THE
AT&T LONG DISTANCE BUILDING, NEW YORK, 1932.

Silhouette mosaic.

Hildreth Meière Dunn

3.6. HILDRETH MEIÈRE, "AUSTRALIA," DETAIL OF THE LOBBY CEILING OF
THE AT&T LONG DISTANCE BUILDING, NEW YORK, 1932.

Silhouette mosaic.

Hildreth Meière Dunn

Mayakovskaya Station by Alexander Deineka dating from 1938. Deineka decided his underground mosaics would provide views of the sky, and in each of them the viewer is given a radical view directly upward—whether toward the underside of a ski jumper or toward Soviet planes in flight. The intense color and extreme durability of glass mosaics, especially for gritty underground train stations, was recognized by the Soviets, and since the 1930s there has been something of an international flowering of subway mosaics.

3.7–3.9. ALEXANDER DEINEKA, MOSCOW SUBWAY CEILING MOSAIC PANELS, MAYAKOVSKAYA STATION, 1938.

Photos by Helen Ackery

The New York City Subway—notorious for years for its rundown stations and graffiti-covered trains—began a renaissance in the early 1980s. The enormous Arts for Transit project, still in process, has already installed more than 160 site-specific pieces in various subway stations. A great number of them are mosaics. Each artist— and many of the best-known New York artists have participated—designed and installed works that vary from pure abstraction (Robert Blackburn's *In Everything There Is a Season* at 116th Street) to realistic figure art (Jack Beal's *Return of Spring* and *Onset of Winter* at Times Square–42nd Street) to the wonderful animals of the 81st Street–Museum of Natural History stop, created by the Arts for Transit Collaborative.[7] The mosaic installations reached a peak in the first decade of the twenty-first century, and they continue.

In any case, when Reiss chose mosaic for the Cincinnati murals in 1931, he had some but not a lot of secular company. Certainly the more famous muralists of the time were not making mosaics. Thomas Hart Benton, Diego Rivera, and Grant Wood, for example, did not create mosaics, nor did the many artists who created murals inside San Francisco's Coit Tower in the 1930s. Neither did the hundreds of artists employed by the Works Progress Administration to create community murals in post offices and schools.

But if Reiss was unusual in his use of secular mosaics in the 1930s, he was right in line with a dominant art movement of the time—the mural movement.

3.10. ARTS FOR TRANSIT COLLABORATIVE, **FOR WANT OF A NAIL** (DETAIL), MOSAIC, 81ST STREET STATION (MUSEUM OF NATURAL HISTORY), NEW YORK SUBWAY, 2000.

Photo by Helen Ackery

3.11. ELIZABETH MURRAY, **BLOOMING** (DETAIL), MOSAIC, LEXINGTON
AVENUE–59TH STREET STATION, NEW YORK SUBWAY, 1996.

Photo by David Allison

THE MURAL MOVEMENT

OF THE 1930S

A SIGNAL OPENING EVENT may be said to have begun the mural movement of the 1930s. This was an important exhibition at the recently opened Museum of Modern Art (MoMA) in New York. The show's creator was Lincoln Kirstein, who was a moving spirit at the museum. *Murals by American Painters and Photographers* was mounted in 1932. As Kirstein wrote in the catalog, "It has taken Mexico to show us the way," referring to the mural work of Diego Rivera, José Clemente Orozco, and David Alfaro Siquieros, whose work was already on the scene in the United States.[8] Kirstein chose thirty-five "American" painters, some foreign-born, for the exhibition. Each presentation showed a proposal for a full mural and a representative panel. Winold Reiss was not included, possibly because he was not yet a citizen (that happened later for Reiss in 1932), or perhaps because Reiss was known more in New York as a decorator. Kirstein revealed his prejudice against that in the catalog when he wrote of "that bastard form of adornment—interior decoration."[9]

The painters were asked to come up with proposals and scaled-down sections of large wall murals. The theme was to be "The Post-War World." Although none of the painted murals were ever realized in full, a few notable painters participated: Stuart Davis, Philip Evergood, William Gropper, Reginald Marsh, Georgia O'Keeffe, and Ben Shahn. None of the artists who would shortly make a name for themselves

as muralists were included: neither Thomas Hart Benton, Grant Wood, John Steuart Curry, Hildreth Meière, nor Winold Reiss.

A remarkable aspect of the *Murals* show was the invitation of twelve photographers (or photographic partnerships). Only one of these photographic murals was ever realized in full, the Charles Sheeler triptych, which was put in mural form many years later. The photographic section of the show was curated by gallery owner Julien Levy. It was the first exhibition of photographers at MoMA.[10]

Behind the scenes, some museum trustees balked at the political content of the proposals, in particular those by Ben Shahn, Hugo Gellert, and William Gropper, but the show was eventually mounted, and Lincoln Kirstein and Julien Levy wrote the catalog. Although none of the murals was actually completed during the thirties, the show itself was important for several reasons: the showcasing of murals as a significant form of contemporary art, the inclusion of photographers, and the unavoidable political content of several artists' work during what, after all, was a severe national depression. These were important impulses as the mural movement unfolded.

Besides the anticapitalist and political sentiment that infused some of the murals in the MoMA show, the Great Depression created a need for an art of popular uplift, or at least popular historical confirmation, along with a need for employment for a great number of artists. The federal Works Progress Administration mural program, begun in 1935, provided artists employment and resulted in hundreds of murals in schools and post offices throughout the country. Although Winold Reiss was never employed by the WPA, and indeed had finished the Cincinnati murals before the WPA began, he was not indifferent to the artistic environment the agency recognized and supported. Murals were in the air, along with a new populist sentiment.

Because the WPA artists were meant to make murals that related to the history, agriculture, or customs of the locations where they were to be painted, there was a natural hometown expectation of accuracy or even flattery. In some cases the artists ignored local criticism and in others yielded to it, but there was plenty of controversy. In later years, many of the murals became as uncontroversial as wallpaper, but when they were painted there were many points of contention.[11]

Another mural movement had preceded the well-known works of the 1930s—the Beaux-Arts mural movement of 1893–1917. During this period a great number

of state capitols, government buildings, banks, monumental office buildings (like the Marquette Building, already mentioned), train stations, museums, and libraries were completed, and the dominant architectural style was Beaux-Arts (or "American Renaissance"), which was inspired and greatly influenced by the neoclassic architecture of the 1893 Columbian Exposition in Chicago. When it came to decorations, the mural artists hired had mostly studied abroad, many at the École des Beaux Arts in Paris. At first, the themes of the murals were symbolic or allegorical—the virtues, law, history, wisdom, justice, and the like for the most part embodied in graceful, idealistic, classically draped female figures. Later, themes included scenes from history, and even more from the present (local industries like coal mining, steel, etc.), and in these, masculine figures began to dominate. However, this flourishing mural movement died out, seen as old-fashioned by the time of the entry of the United States into World War I, and murals would not see a revival until the 1930s.[12]

REGIONALISM

ALONG WITH THE local focus of the WPA murals, a new artistic movement, Regionalism, was also entering the American scene in the 1930s. It has been argued by Henry Adams that the "movement" was the creation of one art dealer, Maynard Walker, and *Time* magazine, which ran a cover story in 1934 on a group of artists who in some cases had never even met each other.[13] However it started, the Regionalists became popular and seemed to embody an interest in a non-European, realistic art that celebrated the traditional values of a country with a troubled history and, with the Great Depression, an even more troubled present.

The Regionalist artists, most notably midwesterners, turned their attention to rural life and celebrated it, far from the turmoil of the cities. Grant Wood, John Steuart Curry, and Thomas Hart Benton were the three most famous Regionalists, and they all painted murals among their other work. Grant Wood was closely connected with Iowa, Curry with Kansas, and Benton most closely with Missouri and Indiana. Of the three, Benton was the great, and most controversial, muralist.

Each of the three artists had a distinct style. Grant Wood's smooth, rounded, unwrinkled forms of tidy farms and individuals made him popular, and the very stand-in for Iowa's agricultural and small-town culture. Strongly influenced by the Flemish painting he saw in Europe in 1928, his best-known painting, *American Gothic* (1930, Art Institute of Chicago), has become an American icon.[14] Wood's murals for the Iowa State University Library at Ames are the artistic highlight of the library. Collectively entitled *When Tillage Begins, Other Arts Follow*, the murals deal with the effects of agricultural settlement. They were sponsored by the WPA and completed in 1936–37 with help from his students at the university.

John Steuart Curry, in contrast to Wood, had a fiery artistic personality, and his greatest mural cycle—commissioned in 1937 for the Kansas Statehouse in Topeka—was abandoned by him in 1942 because of criticism from legislators. (The murals were eventually finished in 1978 by Lumen Martin Winter based on Curry's sketches). The most famous of Curry's murals shows a gigantic, explosive figure of abolitionist John Brown surrounded by his assassins, shouting and waving a Bible in one hand and a rifle in the other. A Kansas tornado and a huge fire enliven the background of the picture.

Thomas Hart Benton was born into a political family in Missouri and spent a childhood between Washington, DC, and Missouri, following his father's career. He eventually struck out as an artist and studied in Paris and Chicago. After a turbulent early path through abstract modernism, Benton declared himself an enemy of modernism and began employing a naturalistic, descriptive style, often involving writhing bodies and tumultuous compositions that tended to raise the temperature of viewers looking at the paintings.

In 1931, Benton completed a cycle of murals for the New School in New York City. With the overall subject of "America Today," the murals advanced his style of muscular description. They also raised the question of Benton's ultimate place as a fine artist. His background as a cartoonist and illustrator seemed to dog his most

3.12. GRANT WOOD, **BREAKING THE PRAIRIE SOD**, 1936–37.

Oil on canvas mural. Parks Library, Iowa State University, Ames, Iowa. Participating artists: Thealtus Albert, Lee Allen, Holland Foster, Richard Gates, Howard Hames, John Hoagland, Joseph Swan, Francis McRay.

serious efforts, and they are subject to critique on that basis. His work—along with his sometimes combative personality—was controversial throughout his life. A unique aesthetic aspect of Benton's New School murals was his use of silver-painted molding (both straight and curved) to divide up sections of his murals. This odd technique may be related to a lingering abstract sense in his work, or to the dominant Art Deco style. Or, as some of his critics averred, these divisions may have been the result of a simple failure by Benton to relate the sections of the murals.

In 1932, Benton got a big breakthrough commission of murals of Indiana life to be painted for the 1933 Century of Progress International Exposition in Chicago. The murals created conflict, though, because they depicted Indiana life as possibly too gritty, including Ku Klux Klan members in full regalia. However, they can still be seen at Indiana University in Bloomington. These murals were exactly contemporaneous with Reiss's Cincinnati murals.

Benton's greatest mural cycle was *A Social History of Missouri*, commissioned in 1935 for the Missouri State Capitol in Jefferson City. Once again, his style and his candor about his subjects—including slavery, the Missouri outlaw Jesse James, and the political boss Tom Pendergast—provided material for controversy. In his political slant, Benton was close to the points of view expressed by the ascendant group of Mexican muralists.

While Benton, Wood, and Curry were well known for their murals, many other painters of the period closely identified with particular regions tended to paint easel paintings, not murals: these included Edward Hopper, Marsden Hartley, Charles Burchfield, Peter Hurd, Georgia O'Keeffe, Charles Sheeler, Reginald Marsh, Charles Demuth, and a number of others in various parts of the country. These are artists who are often clustered under the name of "American Scene" painters. In general they painted in a realist style, but, once again, Winold Reiss did not quite fit with this group. Aside from the enormous exception of the Cincinnati murals, Reiss did not concentrate on particular places or social issues, as the American Scene painters did. He emphasized the individual, not the place—another reason Reiss stands outside the so-called mainstream of his time.

3.13. THOMAS HART BENTON, **AMERICA TODAY**, PANEL C, **CITY ACTIVITIES WITH SUBWAY**, 1930–31.

Egg tempera with oil glazing, 92" × 134".

© VAGA, New York. Image © Metropolitan Museum of Art. Image Source: Art Resource, New York

THE MEXICAN MURAL
MOVEMENT

AT THE SAME time as the Regionalists, the effects of the Mexican Revolutionary artists were being felt in American culture, and especially the artistic influence of the "big three" Mexican muralists: Diego Rivera, José Clemente Orozco, and David Alfaro Siqueiros. These muralists, associated with (if not always direct participants in) the ten-year struggle in Mexico, were socialists or Communists and painted murals that glorified the Mexican struggle—and inspired many artists north of the border. Artists such as Winold Reiss (in 1920) or photographer Edward Weston (in 1923) made trips to Mexico, inspired by the artistic and social ferment there.

When Reiss traveled by train into Mexico in October 1920, very soon after his first trip to Montana and encounter with the Blackfoot Indians, he was inspired by the idea of Mexico's indigenous people. He idealized especially the Mexican Indians, not those of Spanish descent, and during his short stay he painted several superb portraits as well as village scenes, several published in *Survey Graphic*.[15] His letters and diary entries written while in Mexico betray a somewhat naïve perspective. At one point, he claimed, "I am leaving America without sentimentality—into the promised land." Traveling through St. Louis, he decried that city as "impossibly filthy" and spoke of New York as "an empty, squeezed-out lemon." For him, Mexico City was "this wonderful city," although he regretted the presence of so many beggars.[16] Nevertheless, Reiss does not appear to have been drawn into the political ferment in Mexico in 1920, although he was a strong sympathizer.

3.14. WINOLD REISS, **CUERNAVACA**, 1920.

Print on newspaper.

Reiss Archives

His next work did not include any mural-size pieces aside from commercial jobs. Instead, on his return, he made a brief trip back to Europe, where he portrayed peasants in Germany and Sweden. Then, back in the United States, Reiss was drawn into the cultural excitement of the Harlem Renaissance. He created thirteen stunning portraits for an issue of *Survey Graphic*, plus three designs called "interpretations of Harlem Jazz."[17] His Harlem portraits would continue into the next decades.

But, to return to murals: for consideration for the Cincinnati Union Terminal, Winold Reiss seemed to have had much on his side—his successful commercial jobs, his impressive portraits of all kinds of people, the backing of patron Louis Hill of the Great Northern Railway and of Paul Philippe Cret, aesthetic advisor for the terminal project. He got the job, but still was entering an international field dominated by a very few, quite political muralists.

In the United States, Diego Rivera was perhaps the best known, despite the fame of the Regionalists. Rivera was, in every sense of the word, bigger than life. His girth, his personality, his artistic talent, his socialist politics, his exotic wife (painter Frida Kahlo), all made him the most sensational of the mural artists. Rivera was a fierce critic of capitalism, but, oddly, two of the most capitalist of patrons—Edsel Ford in Detroit and John D. Rockefeller in New York—hired him for major mural projects. Despite politics, it is not hard to imagine their desire to have the biggest and the best. And Rivera delivered, with mixed results.

Edsel Ford's commission—generally regarded now as Rivera's masterwork—was created in a great courtyard space in the Detroit Institute of Arts with a giant skylight above and copious wall space, divided by various pilasters and architectural elements. The many fresco murals depict Detroit's auto industry, the repression of the workers, life, death, medicine, agriculture, and ancient Mexican symbols and motifs, which Rivera rendered in terms of colossal industrial machines. Great numbers of figures are densely layered in amongst the many levels of industrial activity. Despite some community disapproval, it was Rivera's greatest scheme, supported by Edsel Ford (who paid for it), and the 1933 murals still stand today.

The Rockefeller commission of 1933 did not fare so well. Meant to be the centerpiece of the new Rockefeller Center in New York, Rivera was given the grand theme by the Rockefellers of "Man at the Crossroads with Hope and High Vision to the Choosing of a New and Better Future." Rivera, of course, had his own ideas.

3.15. DIEGO RIVERA, **DETROIT INDUSTRY**, NORTH WALL (DETAIL), 1932–33.

Fresco mural depicting the important operations in the manufacture of the 1932 Ford V-8.

Detroit Institute of Arts USA / Gift of Edsel B. Ford / Bridgeman Images

Amongst all the figures and futuristic design/technology images, the Rockefeller mural depicted Russian communist leader Vladimir Lenin, just to the right of center, clasping the hands of a white soldier and a black worker. Rivera was not actually a member of the Communist Party in 1933, but later rejoined in 1954, after his wife Frida Kahlo's death.[18] Nevertheless, Communist themes and figures were often included in his murals.

Predictably, the Lenin image caused problems, and Rivera was asked to erase it in a letter from Nelson Rockefeller of May 4, 1933. "Rivera, in response, commented that Lenin's face had appeared since the first sketches and that it was important because for him Lenin represented the greatest leader ever. He explained that 'rather than mutilate the conception, I should prefer the physical destruction of the conception in its entirety, but conserving, at least, its integrity.'"[19] On May 9, Rivera was asked to leave the worksite with his assistants, and was not even allowed to take photographs (luckily, photographs of the partially complete mural have survived). The mural was quickly covered with canvas, and "nine months later . . . beginning at midnight on Saturday, Feb. 10–11, 1934, Rivera's mural was removed from that interior wall by being smashed into small pieces and powder."[20]

The Rockefellers paid Rivera, but destroyed the mural. Always able to capitalize on bad publicity, Rivera used the remainder of his commission money to paint twenty-one murals with a Marxist interpretation of U.S. history for the New Workers School (now all either in private collections or destroyed by fire in 1969). Later in 1934 Rivera repainted the Rockefeller design in the Palace of Fine Arts in Mexico City, now called *Man, Controller of the Universe*, or *Man in the Time Machine*.

In the Mexico City (1934) version, in the center sits a stalwart blond man with his hands on the controls of what appears to be a giant machine with the wings of a dragonfly. Behind and above him are giant wheel and tank forms, and beneath him are all kinds of flowers and fruits growing in a cutaway section of the earth. Crowds of people—men, women, and children, soldiers and workers, as well as some decadent nightclub visitors—are crammed in arrays, most facing the central figure. On the right is the headless figure of a giant statue of Caesar, and on the left a large, bearded statue figure wearing a cross on a chain. As with Benton's work, there is a cartoonish quality to Rivera's great conceptions that lingers, despite his imaginative talent and prodigious works.

WINOLD REISS AT THE
CROSSROADS OF AMERICAN ART

THE COLORFUL CONFLICTS of Rivera do not seem to have touched Winold Reiss. He was a well-liked, devoted American as a new citizen. Although figures in the Cincinnati murals may be holding weapons, they are not engaged in fighting, or, for that matter, even touching or overlapping each other. Reiss has presented a pageant of American history, but it is a history without events—rather like a *tableau vivant*. Events are implied by the movement of the figures across the landscape, and of course by their weapons and tools, but no battles or conflicts are represented. Types of Americans are shown, many kinds of boats and wagons and trains, and, of course, Cincinnati as the centerpiece, but little action is even implied. It is a tableau created by an admirer, a supporter, not an engaged political fighter. In the blue-themed background, the vision of a future Cincinnati offers a scheme of the city to come. It rests upon the past but soars beyond it toward an only imagined future.

In Reiss's Cincinnati panorama, it is hard to imagine anything further from the strife and action represented by Rivera and Benton in their murals, focused as they were on the past and the political struggles of the present day, yet the three were contemporaries. Politically, they were all sympathizers with the struggles of the common people. Benton (with his family legacy of American political life) seemed to have wanted to resurrect and depict the truthful history of the conflicts of the

country, with all its sordid moments. Rivera (a Mexican) seemed to want to reduce people to "masses" and show them in combat poses against the capitalists who were oppressing them. But Reiss (a German immigrant who became a U.S. citizen during the creation of the murals) seemed to appreciate the freedom he felt in the United States, and the whole array of American types. He drew on his greatest strength as an artist, portraiture, to display his admiration of every one of them—the workers in the industrial murals and the more symbolic figures in the rotunda murals. And in this was his vision for the future.

To say that Reiss was in the crossroads of American art might suggest that he was about to get run over. Indeed, in terms of critical opinion, he was sideswiped by his more sensational colleagues at the time. But, in Cincinnati, Reiss created a monument in long-lasting mosaics to his more serene vision of American culture and his belief in its future. This has been a lasting vision, and it is there for us now.

After the Cincinnati project, Reiss was offered a position as assistant professor of mural painting at New York University, and he taught there until 1941. He continued his portrait and mural work but suffered a stroke in 1951 and produced little after that time. He suffered a second, paralyzing stroke in 1952. When he died in 1953, his ashes were scattered on the Blackfoot reservation in Montana, as a gesture of affection and respect from the individuals he had portrayed so beautifully.

Winold Reiss was a unique, talented, and prolific artist of the twentieth century, and the Cincinnati murals are in many respects his greatest achievement, a culmination of his portrait and design work, as well as his statement as a new American interested in the ordinary working people who built the country. Interest in his work is growing. As an example, an international Winold Reiss Symposium was held in December 2011 at the John F. Kennedy Institute at the Free University in Berlin, which brought established Reiss scholars C. Ford Petross and Jeffrey C. Stewart together with a number of newer, international scholars who are engaging in the rediscovery of Reiss. This study is part of that rediscovery—putting the murals in the broad context of the mural movement of the time, as well as putting the murals in the context of Reiss's own large body of work. This reinvestigation of a great artist is sure to continue, and thanks to the Cincinnati "Save the Terminal" group the rotunda murals are still available to the public in their spectacular Art Deco setting at the terminal. For now, at least (when nine of the industry/worker murals

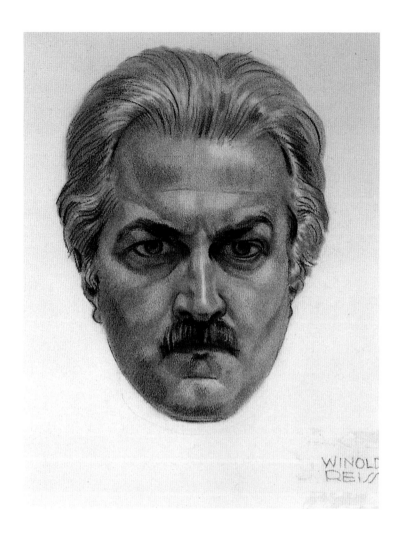

3.16. WINOLD REISS, **SELF PORTRAIT**, PRE-1932.

Pastel, 15$\frac{3}{8}$" × 12$\frac{1}{2}$".

C.M. Russell Museum

again face removal), five of the concourse murals are still viewable at the airport. Professor Gabriel Weisberg wrote in 1972, during the first "Save the Terminal" effort, words that are just as meaningful today:

> Perhaps, if these mosaics have a chance to survive they will appear as significant as Italian Renaissance frescos, mirroring as they do the aspirations of the Queen City in a style that was appropriately modern. . . . It was a true gateway toward a futuristic environmental design, created by a small group of enlightened patrons and artists, and it would be a tragedy for it to perish.[21]

NOTES

PREFACE

1. *Queen City Heritage: Journal of the Cincinnati Historical Society* 51, no. 2/3 (Summer/Fall 1993).

2. After its shutdown as a railroad terminal in 1973, the building was for a time a shopping mall, but finally in 1990 turned into the Cincinnati Museum Center, now housing the Cincinnati History Library and Archives, Museum of Natural History & Science, and an OMNIMAX® theater, among other attractions. The murals and the rotunda may be viewed without any fee.

3. See John F. Kennedy Institute for North American Studies, "Winold Reiss Symposium 2011," http://www.jfki.fu-berlin.de/en/v/winold-reiss. This is the site of "Cultural Mobility and Transcultural Confrontations: Winold Reiss as a Paradigm of Transnational Studies," a symposium held at the Free University of Berlin, December 1–3, 2011. The symposium was organized by Frank Mehring, and the keynote speakers were C. Ford Peatross, Jeffrey C. Stewart, Renate Reiss, and Peter Reiss. Another important site is the Reiss Partnership's http://www.winoldreiss.org/home.html, the official site of the Winold Reiss Archive.

4. Sue Ann Painter, *Architecture in Cincinnati: An Illustrated History of Designing and Building an American City* (Athens: Ohio University Press, 2006), xiii.

PART ONE: THE MURALS

1. Sue Ann Painter, *Architecture in Cincinnati: An Illustrated History of Designing and Building an American City* (Athens: Ohio University Press, 2006), 181.

2. Linda Oliphant Stanford, "Railway Designs by Fellheimer and Wagner, New York to Cincinnati," *Queen City Heritage: Journal of the Cincinnati Historical Society* 43, no. 3 (Fall 1985): 3, quoting Frank Williams, "Grand Central City, *Architectural Forum* 143 (January–February 1968): 50.

3. Randall Lee Schieber and Robin Smith, *Ohio Then and Now: Contemporary Rephotography* (Englewood, CO: Westcliffe, 2006), 82.

4. Daniel Hurley, *Cincinnati: The Queen City* (Cincinnati, OH: Cincinnati Historical Society, 1988), 125.

5. Gregory Thorp, "Its Glory Vanished, Vast Cincinnati Terminal Bows Out," *Smithsonian*, June 1974, 64. Also see Linda Bailey, Barbara Dawson, and Ruby Rogers, *Cincinnati Union Terminal* (Cincinnati, OH: Cincinnati Museum Center, 2003), 3–11, especially the dramatic aerial photographs of the 1937 flood on pages 10–11.

6. Built at a time when the Gothic style had come to dominate university architecture, Columbia's Low Memorial Library (1895) provides many a good example of Beaux-Arts style. It only begins in the staircase, with Daniel Chester French's domineering "Alma Mater."

7. Painter, *Architecture in Cincinnati*, vii.

8. Stanford, "Railway Designs," 20.

9. The Art Deco style took its name from a famous Paris exhibition of 1925: *Exposition Internationale des Arts Décoratifs et Industriels Moderne*. Many "Art Deco" practitioners, including Winold Reiss, simply referred to it as "modernism."

10. Patricia Bayer, *Art Deco Architecture: Design, Decoration and Detail from the Twenties and Thirties* (New York: Harry N. Abrams, 1992), 16.

11. Ibid., 37–41.

12. Linda Rose, Patrick Rose, and Gibson Yungblut, *Cincinnati Union Terminal: The Design and Construction of an Art Deco Masterpiece* (Cincinnati, OH: Cincinnati Railroad Club, 1999), 162.

13. Henry M. Waite, quoted in Jack Donnelly, "Terminal Case: A Great Building Outlives Its Age," *Cincinnati* 6, no. 6 (March 1973): 29–30.

14. Bevis Hillier, *Art Deco of the 20s and 30s* (London: Studio Vista/Dutton Pictureback, 1968), 13.

15. Winold Reiss, "The Modern German Poster," *M.A.C. [Modern Art Collector]* 1, no. 1, 1915.

16. Denny Carter, "Paul Philippe Cret and the Union Terminal," in *Art Deco and the Cincinnati Union Terminal*, exhibition catalog, ed. University of Cincinnati, Department of Art History (Cincinnati, OH: Contemporary Arts Center, 1973), 10–14.

17. Cincinnati Museum Center, "The Glass Storybook and the Great Menagerie: The Art of Winold Reiss and Pierre Bourdelle," http://www.cincymuseum.org/unionterminal/art.

18. The three paintings (or "cartoons") that were to be the basis for the Chrysler murals depicted Indians. He gave them to his friend Otto Baumgarten, who sold them to a Mrs. Rollinson in 1933. Her family (the DeMooys) still have them, according to an e-mail of 2007 in the Reiss Archive.

19. Owen Findsen, *Cincinnati Enquirer*, October 2, 1983.

20. *To Color America: Portraits by Winold Reiss*, exhibition catalog, ed. Jeffrey C. Stewart (Washington, DC: Smithsonian Institution for the National Portrait Gallery, 1989), 96–97. The second paragraph draws from an interview with Tjark Reiss, July 25, 1987.

21. Tommy West, "Concourse Murals Can Be Moved in One Piece," *Cincinnati Post*, December 15, 1972. St. Louis University Libraries Special Collections, Ravenna Mosaic Company Records (DOC REC 50).

22. See John Droege, *Passenger Terminals and Trains* (1916; repr., Milwaukee, WI: Kalmbach, 1969), 1–8.

23. Winold Reiss to W. J. Cameron of the Ford Motor Company, November 22, 1940, Reiss Archive.

24. Reiss worked with the Blackfoot: this group includes the Blackfoot, Piegan, and Blood tribes.

25. The officers have been identified by Asta von Buch in her paper, "A German View of American History? Winold Reiss's Mosaics at Cincinnati Union Terminal, 1931–33," in *American Artists in Munich: Artistic Migration and Cultural Exchange Processes*, ed. C. Fuhrmeister, H. Kohle, and V. Thielemans (Berlin: Deutscher Kunstverlag, 2009), 218. The information about Filson and Patterson is from Wikipedia.

26. Leutze's most famous work was *Washington Crossing the Delaware* (1850).

27. A man named "York" posed for this figure. The model for the man with the pickaxe or mattock was Howard Pettibone. Both these identifications are according to Gregory Thorp.

28. The Federal blockade of Southern ports made it advantageous for the southern cotton growers to sell their product to the Northern dealers for gold, which gave the South money they needed and allowed the export of cotton to foreign or New England textile manufacturers: "The money, after all, was very good. By the fall of 1862 a combination of an initial Southern embargo and a tightening Federal naval blockade created a scarcity that inflated cotton prices. Behind Confederate lines the staple could be purchased at 10 cents a pound, but was worth 70 cents or more in Northern or overseas markets." Phil Leigh, "Trading with the Enemy," *Opinionator* (blog), *New York Times*, October 12, 2012, http://opinionator.blogs.nytimes.com/2012/10/28/trading-with-the-enemy.

29. For a contemporary account, see "The Cincinnati Cotton Trade: A Business That Is Languishing Because of Low Railway Rates," *New York Times*, June 15, 1883.

30. The engineer is a portrait of John Lester, an engineer for the Southern Railroad. Gregory Thorp, "My Encounter with Reiss," *Queen City Heritage: Journal of the Cincinnati Historical Society* 51, no. 2/3 (Summer/Fall 1993): 23. Reiss's son Tjark Reiss posed for the surveyor.

31. For Reiss, depicting African Americans and Indians was perhaps more natural, based on his long experience by then with people in Harlem and among the Blackfoot, many of whom served as subjects and models for his art.

32. Reiss's brother Hans Reiss posed for the father.

33. A National Homestead Monument is located in Beatrice, Nebraska, on the site of the homestead of Daniel Freeman, the first homesteader. The Homestead Act was repealed in 1976, except in regard to Alaska, where it was continued until 1986. Little homesteading took place after the 1930s.

34. Timothy Egan's *The Worst Hard Time: The Untold Story of Those Who Survived the Great American Dust Bowl* (New York: Houghton Mifflin, 2005) examines the agricultural practices (mainly plowing up all the natural grassland) that largely caused this devastation.

35. Frances Crotty, "The Cincinnati Union Terminal and the Art Deco Movement" (master's thesis, University of Cincinnati, 1972), 51.

36. These come from Renate Reiss, correspondence with the author, February 13, 2013.

37. The photographs are now archived at the Cincinnati Museum Center Library and Archives.

38. Letter from Arno Heuduck to Frances Crotty, July 17, 1972. St. Louis University Libraries Special Collections, Ravenna Mosaic Company Records (DOC REC 50).

39. The two half-size mosaics depicting workers at the city's famous Rookwood Pottery were moved in 1990 as part of the conversion of Cincinnati Union Terminal to a museum complex; they were installed in the special exhibits gallery on the lower level (which was later used for the Cincinnati History Museum's exhibit *Forming A New World: Cincinnati's Machine Tool Industry, 1850–1930*). Two more depict arriving and departing trains: they were directly above the arrivals/departures boards and are now just outside the Cincinnati Museum Center Library. In 1942, the Gruen Watch Company of Cincinnati asked for a mural in the Concourse, and Reiss did a proposal drawing. This would have replaced the "arriving train" mosaic. However, nothing ever came of it. Letter from Winold Reiss to Paul Heuduck, December 9, 1942. St. Louis University Libraries Special Collections, Ravenna Mosaic Company Records (DOC REC 50).

40. Gabriel Weisberg to Arno Heuduck, March 3, 1973. St. Louis University Libraries Special Collections, Ravenna Mosaic Company Records (DOC REC 50).

41. Arno Heuduck to George Wehner, February 25, 1974. Heuduck estimated replacement costs for the fourteen mosaics to be $150,750 (not including any fees to the artist, which he later assessed as approximately $3,000 per mural). Two letters dated February 25, 1974, in the St. Louis University Libraries Special Collections, Ravenna Mosaic Company Records (DOC REC 50).

42. Tommy West, "Concourse Murals Can Be Removed in One Piece," *Cincinnati Post*, December 15, 1972.

43. Gabriel Weisberg, "A Terminal Case Revisited: The Preservation of Cincinnati's Union Terminal Concourse Mosaics," *Art Journal* 33, no. 4 (Summer 1974): 328–30.

44. Cliff Radel, "CVG Plans Put Historic Murals in Peril: Union Terminal's Old Murals Are Facing the Wrecking Ball. Again," *Cincinnati Enquirer*, April 28, 2013.

PART TWO: THE ARTIST

1. In 1931, P. W. Sampson observed that "Winold Reiss is a product of the Kunstgewerbeschule [School of Applied Art, Munich, Germany], in which the young Continental art student is given a thorough training in all the fields of artistic endeavor. This is unlike the American art schools, in which the student receives specialized training." P. W. Sampson, "A Modern Cellini —Winold Reiss," *DuPont Magazine* 25, no. 3 (March 1931).

2. John Heminway, "An Immigrant Artist Captured the Faces of the New World," *Smithsonian* 20, no. 8 (November 1989): 176.

3. C. Ford Peatross, "Winold Reiss: a Pioneer of Modern American Design," *Queen City Heritage: Journal of the Cincinnati Historical Society* 51, no. 2/3 (Summer/Fall 1993): 38–55.

4. For a list, see http://www.winoldreiss.org/works/murals, which includes small illustrations of each mural.

5. See Jeffrey C. Stewart, *Winold Reiss: An Illustrated Checklist of His Portraits* (Washington, DC: Smithsonian Institution for the National Portrait Gallery, 1990). Testifying to his energy, a

1922 show at the Anderson Galleries in New York included an astonishing 139 portraits from Mexico, Oberammergau and the Black Forest in Germany, and Sweden (1922 exhibition catalog from the Anderson Galleries). This show did not include any of the Blackfoot portraits.

6. Student Sarah Frijofson, quoted in the exhibition catalog *To Color America: Portraits by Winold Reiss*, ed. Jeffrey C. Stewart (Washington, DC: Smithsonian Institution for the National Portrait Gallery, 1989), 105.

7. Now in the Bradford Brinton Memorial and Museum in Big Horn, Wyoming.

8. The essay is reproduced in the 1922 catalog for Reiss's show at the Anderson Galleries.

9. *Century Magazine*, September 1922, quoted in *Winold Reiss, 1886–1953, Centennial Exhibition: Works on Paper: Architectural Designs, Fantasies and Portraits*, ed. Elisabeth Kashey and Robert Kashey (New York: Shepherd Gallery, 1987), unpaginated, note 67.

10. Copies of these issues of *Survey Graphic* can be found in the Reiss Archive.

11. Stewart in his keynote address at the December 2011 symposium on Winold Reiss. John F. Kennedy Institute for North American Studies, "Winold Reiss Symposium 2011," http://www.jfki.fu-berlin.de/en/v/winold-reiss.

12. Sean Wilentz, *Bob Dylan in America* (New York: Doubleday, 2010), 29.

13. Ibid., 30–31.

14. Stewart, *Winold Reiss: An Illustrated Checklist of His Portraits*, 8.

15. See Malvina Hoffman, *Heads and Tales* (New York: Scribners, 1936), for her own account of the project.

16. August Sander, *People of the 20th Century*, ed. Susanne Lange and Gabriele Conrath-Scholl, 7 vols. (New York: Harry N. Abrams, 2002).

17. Robert W. Bye, "Great Northern Calendars: 1928–1958," Reference Sheet 166, June 1990, Great Northern Railway Historical Society.

18. *Youth and Beauty: Art of the American Twenties*, exhibition catalog, ed. Theresa A. Carbone (New York: Brooklyn Museum/Skira, 2011), 177.

19. Although records are not conclusive, it seems that mosaic work could have been done by Emil Frei in St. Louis or the Puhl & Wagner company in Germany, then shipped to Ravenna Mosaic in New York City for assembly, and then of course shipped to and installed in Cincinnati. The histories of these companies are intertwined. The first was the Emil Frei company, founded by the German immigrant in St. Louis primarily for the construction of the mosaics in the St. Louis Cathedral. Frei then joined with the German Puhl & Wagner company. Paul Heuduck emigrated from Germany at the behest of Puhl & Wagner and helped establish Ravenna Mosaic. The Ravenna company moved to New York City in 1929, but then eventually back to St. Louis. The Ravenna company was eventually credited (with a signature under Reiss's) for the mosaics, but there was an active collaboration between Frei, Puhl & Wagner, and Ravenna. Frei eventually broke with Ravenna over the course of late 1929 to 1930. See Robert Blaskiewicz, "Paul Johannes Heuduck, 1882–1972," *American National Biography: Supplement 2*, ed. Marc C. Carnes (New York: Oxford University Press, 2005): 250–52.

In the Ravenna archives at the University of St. Louis, Paul Heuduck "states that most of the mosaics were executed in Ravenna's studio in New York, the rest in Berlin, and that 'Reiss

could pick out every panel that was done in our studios because they were of superior artistic craftsmanship.'" St. Louis University Libraries Special Collections, Ravenna Mosaic Company Records (DOC REC 50), Series 7, Folder 8, 7-17-72.

20. Letter from Winold Reiss to Tjark Reiss, March 30, 1932, Reiss Archive.

PART THREE: THE CONTEXT

1. Letter from Winold Reiss to Tjark Reiss, October 31, 1931. Reiss Archive.

2. A mosaic portrait of Sitting Bull was sold to Mrs. Beatrice Mack and Mr. N. F. Mack, designed by Winold Reiss and crafted by Paul Heuduck around 1930. Carl Solway purchased a mosaic depiction of Mike Little Dog, one of the two made for consideration for the Cincinnati job. St. Louis University Libraries Special Collections, Ravenna Mosaic Company Records (DOC REC 50), Series 3: folder 233-7402, and Series 3: folder 239-7408.

3. One is now in the Wolfsonian Foundation collection in Miami, another in the Glenbow Museum in Calgary.

4. Large cartoons for several of the figures in the north mosaic can be seen in the History Museum at the Cincinnati Museum Center.

5. See James Scott, *Worlds of Bright Glass: The Ravenna Mosaic Company*, DVD (St. Louis, MO: St. Louis University, with KETC-TV, 1992).

6. The designer was Jacob Holzer.

7. A list from the excellent book *Along the Way: MTA Arts for Transit*, by Sandra Bloodworth and William Ayres (New York: Monacelli Press, 2006), includes the following mosaic installations (other art in the subways—sculpture, painting—is not listed here):

> Jacob Lawrence, *New York in Transit*, Times Square–42nd Street, 2001
>
> Jack Beal, *The Return of Spring* and *The Onset of Winter*, Times Square–42nd Street, 2001/2005
>
> Lisa Dinhofer, *Losing My Marbles*, 42nd Street–Port Authority Bus Terminal, 2003
>
> Samm Kunce, *Under Bryant Park*, 42nd Street–Bryant Park, 2002
>
> Jackie Ferrara, *Grand Central: Arches, Towers, Pyramids*, Grand Central–42nd Street, 2000
>
> Ellen Driscoll, *As Above, So Below*, Grand Central North, MTA Metro-North Railroad, 1998
>
> Al Held, *Passing Through*, Lexington Avenue–53rd Street, 2004
>
> Eric Fischl, *Garden of Circus Delights*, 34th Street–Penn Station, 2001
>
> Elizabeth Murray, *Stream*, Court Square–23rd Street (Ely Avenue), 2001, and *Blooming*, Lexington Avenue–59th Street, 1996
>
> Peter Sis, *Happy City*, 86th Street, 2004
>
> Robert Kushner, *4 Seasons Seasoned*, 77th Street, 2004

Robert Blackburn, *In Everything There Is a Season*, 116th Street, 2005

Valelrie Maynard, *Polyrhythmics of Consciousness and Light*, 125th Street, 2003

Vincent Smith, *Minton's Playhouse/The Movers and Shakers*, 116th Street, 1999

Willie Birch, *Harlem Timeline*, 135th Street, 1995

Faith Ringgold, *Flying Home: Harlem Heroes and Heroines*, 125th Street, 1996

Sheila Levrant de Bretteville, *At the Start . . . At Long Last*, Inwood–207th Street, 1999

Arts for Transit Collaborative, *For Want of a Nail*, 81st Street–Museum of Natural History, 2000

Nancy Spero, *Artemis, Acrobats, Divas, and Dancers*, 66th Street–Lincoln Center, 2001

Ming Fay, *Shad Crossing* and *Delancy Orchard*, Delancey Street–Essex Street, 2004

Kristin Jones and Andrew Ginzel, *Oculus*, Chambers Street–Park Place, 1998

Ellen Harvey, *Look Up, Not Down*, Queens Plaza, 2005

Owen Smith, *An Underground Movement: Designers, Builders, Riders*, 36th Street, 1998

Helene Brandt, *Room of Tranquility*, 161st Street–Yankee Stadium, 2002

Roy Nicholson, *Morning Transit, Hempstead Plain* and *Evening Transit, Hempstead Plain*, Hicksville Station, MTA Long Island Rail Road, 2001

Another sixteen or more mosaics are also included in the book *Along the Way*.

8. *Murals by American Painters and Photographers*, exhibition catalog, ed. Lincoln Kirstein and Julien Levy (New York: Museum of Modern Art, 1932), 10.

9. Ibid., 7.

10. Among the twelve photographers (or photographic partnerships) included were the well-known Berenice Abbott, George Platt Lynes, Charles Sheeler, and Edward Steichen. Several innovative techniques were employed: montage, double-printing, positive-negative printing. Ibid., unpaginated section.

11. Michael Kammen, "The Trouble with Murals," chapter 4 of *Visual Shock: A History of Art Controversies in American Culture* (New York: Alfred A. Knopf, 2006.)

12. For an account of this earlier period, see Bailey Van Hook, *The Virgin and the Dynamo: Public Murals in American Architecture, 1893–1917* (Athens: Ohio University Press, 2003.)

13. Henry Adams, *Thomas Hart Benton: An American Original* (New York: Alfred A. Knopf, 1989), 216–21.

14. Ibid., 216.

15. See Katherine Anne Porter, ed., "Mexico: A Promise," special issue, *Survey Graphic* 5 (May 1, 1924).

16. All quotes about the trip were read by Renate Reiss and Peter Reiss at the Berlin symposium in 2011. John F. Kennedy Institute for North American Studies, "Winold Reiss Symposium 2011," http://www.jfki.fu-berlin.de/en/v/winold-reiss.

17. Alain Locke, ed., "Harlem: Mecca of the New Negro," special issue, *Survey Graphic* 6, no. 6 (March 1925).

18. Leticia Alvarez, "The Influence of the Mexican Muralists in the United States: From the New Deal to Abstract Expressionism" (master's thesis, Virginia Polytechnic Institute and State University, 2001), 13.

19. Ibid., 22, quoting Irene Herner de Larrea, "Diego Rivera's Mural at the Rockefeller Center."

20. Kammen, *Visual Shock*, 130–31.

21. Gabriel P. Weisberg, "In My Opinion," *Cincinnati Post*, August 14, 1972. St. Louis University Libraries Special Collections, Ravenna Mosaic Company Records (DOC REC 50).

BIBLIOGRAPHY

Adams, Henry. *Thomas Hart Benton: An American Original*. New York: Alfred A. Knopf, 1989.

Alvarez, Leticia. "The Influence of the Mexican Muralists in the United States: From the New Deal to Abstract Expressionism." Master's thesis, Virginia Polytechnic Institute and State University, 2001.

Art Deco and the Cincinnati Union Terminal. Edited by University of Cincinnati, Department of Art History. Cincinnati, OH: Contemporary Arts Center, 1973. Exhibition catalog.

August Sander: Photographs of an Epoch, 1904–1959. Essays by Beaumont Newhall and Robert Kramer. Millerton, NY: Philadelphia Museum of Art, with Aperture, 1980. Exhibition catalog.

Bailey, Linda, Barbara Dawson, and Ruby Rogers. *Cincinnati Union Terminal*. Cincinnati, OH: Cincinnati Museum Center, 2003.

Bayer, Patricia. *Art Deco Architecture: Design, Decoration and Detail from the Twenties and Thirties*. New York: Harry N. Abrams, 1992.

Blaskiewicz, Robert. "Paul Johannes Heuduck, 1882–1972." In *American National Biography: Supplement 2*, edited by Mark C. Carnes, 250–52. New York: Oxford University Press, 2005.

Bloodworth, Sandra, and William Ayres. *Along the Way: MTA Arts for Transit*. New York: Monacelli, 2006.

Brawer, Catherine Coleman, and Kathleen Murphy Skolnik. *The Art Deco Murals of Hildreth Meière*. New York: Andrea Monfried Editions, 2014.

Bye, Robert W. "Great Northern Calendars: 1928–1958." Reference Sheet 166, June 1990, Great Northern Railway Historical Society.

Cincinnati Museum Center. "The Glass Storybook and the Great Menagerie: The Art of Winold Reiss and Pierre Bourdelle." Accessed October 27, 2015. http://www.cincymuseum.org/unionterminal/art.

"Cincinnati's Magnificent Mistake." *Cincinnati Horizons: The Magazine of the University of Cincinnati*, October 1972. Cincinnati Museum Center archives.

Crotty, Frances. "The Cincinnati Union Terminal and the Art Deco Movement." Master's thesis, University of Cincinnati, 1972.

D'Emilio, Sandra, and Suzan Campbell. *Visions and Visionaries: The Art and Artists of the Santa Fe Railway*. Salt Lake City, UT: Peregrine Smith, 1991.

Dennis, James M. *Renegade Regionalists: The Modern Independence of Grant Wood, Thomas Hart Benton, and John Steuart Curry*. Madison: University of Wisconsin Press, 1998.

Donnelly, Jack. "Terminal Case: A Great Building Outlives Its Age." *Cincinnati* 6, no. 6 (March 1973): 26–45.

Downs, Linda Bank. *Diego Rivera: The Detroit Industry Murals*. New York: Detroit Institute of Arts, with W. W. Norton, 1999.

Droege, John A. *Passenger Terminals and Trains*. 1916. Reprint, Milwaukee, WI: Kalmbach, 1969.

Ellis, Simone. *Santa Fe Art*. New York: Crescent, 1993.

Field Museum. "Malvina Hoffman." Accessed October 27, 2015. https://www.fieldmuseum.org/malvina-hoffman.

Flowers, Bee. *Moscow Metro Panoramas*. London: Blurb, 2010.

Grant Wood: The Regionalist Vision. Edited by Wanda Corn. New Haven, CT: Minneapolis Institute of Arts, with Yale University Press, 1983. Exhibition catalog.

Heminway, John. "An Immigrant Artist Captured the Faces of the New World." *Smithsonian* 20, no. 8 (November 1989): 172–83.

Hillier, Bevis. *Art Deco of the 20s and 30s*. London: Studio Vista/Dutton Pictureback, 1968.

Hurley, Daniel. *Cincinnati: The Queen City*. Cincinnati, OH: Cincinnati Historical Society, 1988.

———."A Vision of Cincinnati: The Worker Murals of Winold Reiss." *Queen City Heritage: Journal of the Cincinnati Historical Society* 51, no. 2/3 (Summer/Fall 1993): 81–96.

Illusions of Eden: Visions of the American Heartland. Edited by Robert Stearns. Minneapolis, MN: Arts Midwest Minneapolis and Ohio Arts Council, 2000. Exhibition catalog.

John F. Kennedy Institute for North American Studies. "Winold Reiss Symposium 2011." Site of "Cultural Mobility and Transcultural Confrontations: Winold Reiss as a Paradigm of Transnational Studies," symposium held at the Free University of Berlin, December 1–3, 2011. Accessed October 27, 2015. http://www.jfki.fu-berlin.de/en/v/winold-reiss.

Kammen, Michael. *Visual Shock: A History of Art Controversies in American Culture*. New York: Alfred A. Knopf, 2006.

Locke, Alain, ed. "Harlem: Mecca of the New Negro." Special issue, *Survey Graphic* 6, no. 6 (March 1925).

Mehring, Frank. "'The Unfinished Business of Democracy': Transcultural Confrontations in the Portraits of the German-American Artist Winold Reiss." In *American Artists in Munich: Artistic Migration and Cultural Exchange Processes*, edited by C. Fuhrmeister, H. Kohle, and V. Thielemans, 193–210. Berlin: Deutscher Kunstverlag, 2009.

Murals by American Painters and Photographers. Edited by Lincoln Kirstein and Julien Levy. New York: Museum of Modern Art, 1932. Exhibition catalog.

National Portrait Gallery (Smithsonian Institution) and Marc Pachter. *Portrait of a Nation: Highlights from the National Portrait Gallery*. New York: Merrell, 2006.

The North American Indians: A Selection of Photographs by Edward S. Curtis. Edited by Joseph Epes Brown. New York: Philadelphia Museum of Art, with Aperture, 1972. Exhibition catalog.

Painter, Sue Ann. *Architecture in Cincinnati: An Illustrated History of Designing and Building an American City*. Athens: Ohio University Press, 2006.

Peatross, C. Ford. "Winold Reiss: A Pioneer of Modern American Design." *Queen City Heritage: Journal of the Cincinnati Historical Society* 51, no. 2/3 (Summer/Fall 1993): 38–55.

Porter, Katherine Anne, ed. "Mexico: A Promise." Special issue, *Survey Graphic* 5 (May 1, 1924).

Radel, Cliff. "CVG Plans Put Historic Murals in Peril: Union Terminal's Old Murals Are Facing the Wrecking Ball. Again." *Cincinnati Enquirer*, April 28, 2013.

Reiss Partnership. *Winold Reiss*. Last modified October 15, 2014. http://www.winoldreiss.org/home.html.

Reiss, Winold. Cover and "Harlem Types." In "Harlem: Mecca of the New Negro," edited by Alain Locke. Special issue, *Survey Graphic* 6, no. 6 (March 1925).

———. "The Modern German Poster." *M.A.C. [Modern Arts Collector]* 1, no. 1, 1915.

Reiss, W. Tjark. "My Father Winold Reiss." *Queen City Heritage: Journal of the Cincinnati Historical Society* 51, no. 2/3 (Summer/Fall 1993): 58–80.

———. "Winold Reiss." In *Winold Reiss*, edited by Bradford Brinton Memorial and Springfield Art Museum. Big Horn, WY: Bradford Brinton Memorial, 2000. Exhibition catalog.

Rose, Linda, Patrick Rose, and Gibson Yungblut. *Cincinnati Union Terminal: The Design and Construction of an Art Deco Masterpiece*. Cincinnati, OH: Cincinnati Railroad Club, 1999.

Sampson, P. W. "A Modern Cellini—Winold Reiss." *DuPont Magazine* 25, no. 3 (March 1931).

Schieber, Randall Lee, and Robin Smith. *Ohio Then and Now: Contemporary Rephotography*. Englewood, CO: Westcliffe, 2006.

Scott, Amy. *The Taos Society of Artists: Masters and Masterworks*. Santa Fe, NM: Gerald Peters Gallery, 1998.

Scott, James. "The Ravenna Company and American Mural Art." Unpublished manuscript, 2003. http://www.libraries.slu.edu/a/digital_collections/Ravenna/RAVENNA+GRAPHICS.pdf.

———. *Worlds of Bright Glass: The Ravenna Mosaic Company*. DVD. St. Louis, MO: St. Louis University, with KETC-TV 1992.

Stanford, Linda Oliphant. "Railway Designs by Fellheimer and Wagner, New York to Cincinnati." *Queen City Heritage: Journal of the Cincinnati Historical Society* 43, no. 3 (Fall 1985): 3–24.

Stewart, Jeffrey C. *Winold Reiss: An Illustrated Checklist of His Portraits*. Washington: Smithsonian Institution for the National Portrait Gallery, 1990.

———. "Winold Reiss as a Portraitist." *Queen City Heritage: Journal of the Cincinnati Historical Society* 51, no. 2/3 (Summer/Fall 1993): 3–19.

Stewart, Jeffrey C., C. Ford Peatross, et al. "Winold Reiss Chronology." Last modified June 14, 2014. http://www.winoldreiss.org/life/chronology.htm.

St. Louis University Libraries Special Collections. Ravenna Mosaic Company Records (DOC REC 50), 1900–1989.

Tanner, Scott. "A Biography of Winold Reiss." Reference Sheet no. 242, June 1996, Great Northern Railway Historical Society.

Thorp, Gregory. "Its Glory Vanished, Vast Cincinnati Terminal Bows Out." *Smithsonian*, June 1974, 64–68.

———. "My Encounter with Reiss." *Queen City Heritage: Journal of the Cincinnati Historical Society* 51, no. 2/3 (Summer/Fall 1993): 20–37.

To Color America: Portraits by Winold Reiss. Edited by Jeffrey C. Stewart. Washington, DC: Smithsonian Institution for the National Portrait Gallery, 1989. Exhibition catalog.

Van Hook, Bailey. *The Virgin and the Dynamo: Public Murals in American Architecture, 1893–1917.* Athens: Ohio University Press, 2003.

von Buch, Asta. "A German View of American History? Winold Reiss's Mosaics at Cincinnati Union Terminal, 1931–33." In *American Artists in Munich: Artistic Migration and Cultural Exchange Processes*, edited by C. Fuhrmeister, H. Kohle, and V. Thielemans, 211–24. Berlin: Deutscher Kunstverlag, 2009.

Weisberg, Gabriel. "A Terminal Case Revisited: The Preservation of Cincinnati's Union Terminal Concourse Mosaics." *Art Journal* 33, no. 4 (Summer 1974): 328–30.

West, Tommy. "Concourse Murals Can Be Removed in One Piece." *Cincinnati Post*, December 15, 1972.

Wilentz, Sean. *Bob Dylan in America.* New York: Doubleday, 2010.

Winold Reiss, 1886–1953, Centennial Exhibition: Works on Paper: Architectural Designs, Fantasies and Portraits. Edited by Elisabeth Kashey and Robert Kashey. New York: Shepherd Gallery, 1987. Exhibition catalog.

Winold Reiss: Plains Portraits. Essays by Rudolf G. Wunderlich and John C. Ewers. New York: Kennedy Galleries, 1972. Exhibition catalog.

Winold Reiss, Portraits of the Races: "Art Has No Prejudice." Text by Paul Raczka. Great Falls, MT: C. M. Russell Museum, 1986. Exhibition catalog.

Youth and Beauty: Art of the American Twenties. Edited by Theresa A. Carbone. New York: Brooklyn Museum/Skira, 2011. Exhibition catalog.

INDEX

Page numbers in italics refer to illustrations.